Create Your Own
TAROT CARDS

A step-by-step guide to designing a unique
and personalized tarot deck

THERESA REED the tarot lady
ADRIANNE HAWTHORNE of ponnopozz

Inspiring | Educating | Creating | Entertaining

Brimming with creative inspiration, how-to projects, and useful information to enrich your everyday life, quarto.com is a favorite destination for those pursuing their interests and passions.

First published in 2022 by Walter Foster Publishing, an imprint of The Quarto Group. 100 Cummings Center, Suite 265D, Beverly, MA 01915, USA.
T (978) 282-9590 **F** (978) 283-2742 **www.quarto.com** • **www.walterfoster.com**

Walter Foster Publishing titles are also available at discount for retail, wholesale, promotional, and bulk purchase. For details, contact the Special Sales Manager by email at specialsales@quarto.com or by mail at The Quarto Group, Attn: Special Sales Manager, 100 Cummings Center, Suite 265D, Beverly, MA 01915, USA.

ISBN: 978-0-7603-7595-2

Digital edition published in 2012
eISBN: 978-0-7603-7596-9

Proofreading by Samuel McGoldrick, Tessera Editorial

Printed in China
10 9 8 7 6 5 4 3 2 1

TABLE OF CONTENTS

WHAT IS TAROT?

BY THERESA REED
aka The Tarot Lady

Perhaps you're already familiar with the tarot, and that's why you picked up *Create Your Own Tarot Cards*. Or maybe you're not sure what it's about, but you've seen a card in the movies or on your social media feed and you're curious. Of course, it's also possible you've never heard of tarot, but here you are, holding this book in your hands.

I remember how I felt when I purchased my first tarot deck. I snatched it up on an impulse while browsing the teeny metaphysical section at a bookstore in the mall. At that time, I was keenly interested in decoding my future, so it was only natural the tarot would catch my eye. That was more than 40 years ago, and I've had a deck in hands ever since.

Back when I began exploring the cards, there was a lot of stigma around them. But now? It's out of the closet, and many people love collecting different decks. These days, there are also so many to choose from! In a way, tarot has gone "mainstream," making it much easier for folks to learn about it.

But if you're entirely new, have no fear. I'm going to give you a clear and concise rundown of what tarot is all about and how to work with it in a way that empowers you, the reader, or anyone you decide to read for.

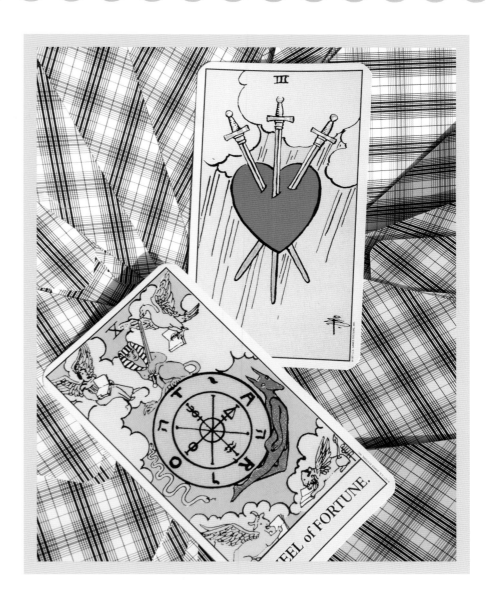

A BRIEF HISTORY OF TAROT

By now, you're aware that tarot is a deck of cards. You might also know they are used for divination. However, when you explore the history of the cards, you'll see they had nothing to do with telling the future. In fact, tarot evolved from playing cards.

Sometime in the 1400s, the cards made their way to Italy, where 22 "triumph," or "trump," cards were added to the deck. These 22 cards became what we now call the major arcana. Back then, tarot was hand-painted by artists, which made them expensive and rare—a privilege enjoyed by the upper classes. It wasn't until the printing press was invented that more people could enjoy them. Some of the older decks were woodcut prints, and uncut images were used as bookbinding. These images can be found in museums around the world.

Divination became associated with the tarot during the 1700s, when Jean-Baptiste Alliette, also known as Etteilla, published a book with divinatory meanings assigned to each card. Tarot became forever seen as a fortune-telling device.

In 1909, the mystic Arthur Edward Waite worked with artist Pamela Colman Smith to create the Rider-Waite deck (now called the Rider-Waite Smith). It became hugely popular, and many modern tarot cards are based on the imagery. In 1960, Eden Gray released one of the first mass-published books on how to read the Rider-Waite Smith deck and the tarot became accessible—and trendy.

Nowadays, tarot isn't simply for seeing the future. It's used for introspection, therapy, and creativity. People are combining it with other modalities and finding new ways to enjoy the tarot all the time.

Now that you have an idea of where the tarot came from, let's talk about what tarot is...and isn't.

Tarot is a deck comprised of 78 cards.

That's it.

Within those 78 cards are two parts: the Major and Minor Arcana. As you may recall, 22 "trump" cards were added to playing cards. These 22 are the majors.

The Major Arcana reflects the bigger picture, life lessons, and our spiritual journey. It shows our purpose, as well as the twists and turns that shape our destiny.

The Minor Arcana contains 56 cards. These represent our daily life and struggles, as well as the people who are involved. It's the situations we have some control over.

MAJOR ARCANA

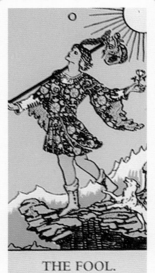

THE FOOL.

THE MAGICIAN.

THE HIGH PRIESTESS.

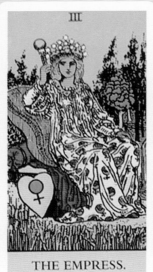

THE EMPRESS.

THE EMPEROR.

THE HIEROPHANT.

THE LOVERS.

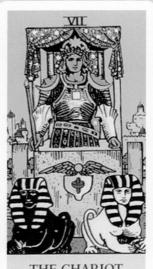

THE CHARIOT.

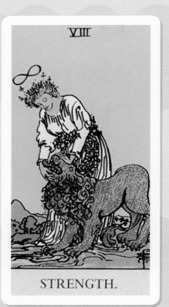

STRENGTH.

THE HERMIT.

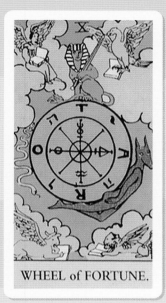

WHEEL of FORTUNE.

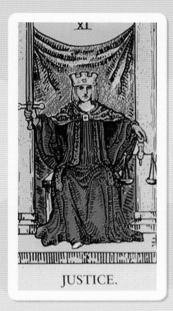

JUSTICE.

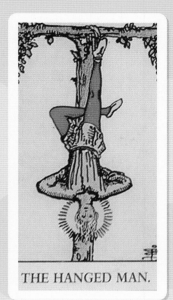

THE HANGED MAN.

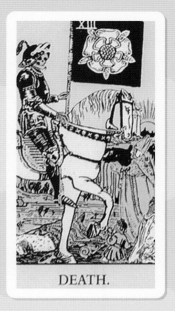

DEATH.

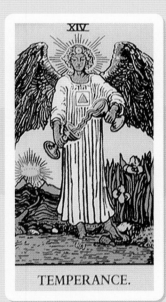

TEMPERANCE.

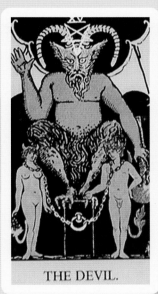

THE DEVIL.

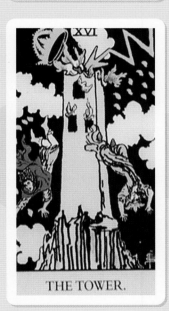

THE TOWER.

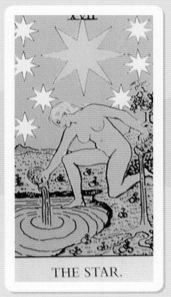

THE STAR.

THE MOON.

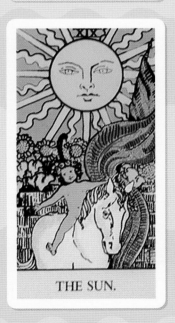

THE SUN.

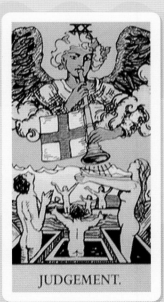

JUDGEMENT.

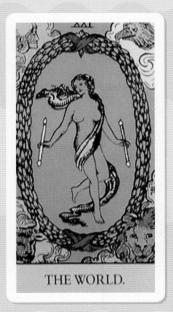

THE WORLD.

MINOR ARCANA

SUIT OF WANDS

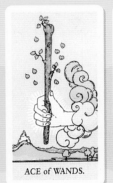

ACE of WANDS.

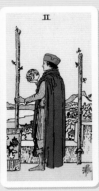

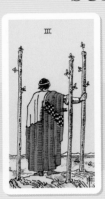

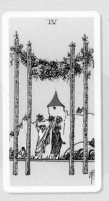

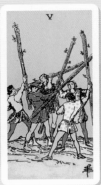

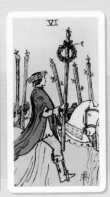

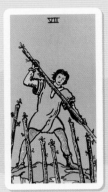

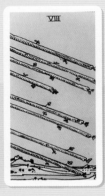

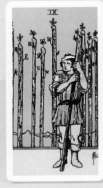

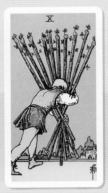

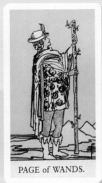

PAGE of WANDS.

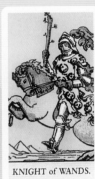

KNIGHT of WANDS.

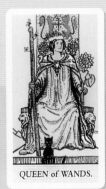

QUEEN of WANDS.

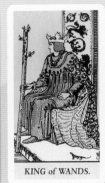

KING of WANDS.

SUIT OF CUPS

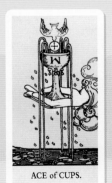

ACE of CUPS.

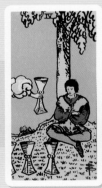

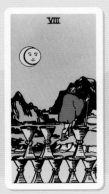

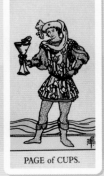

PAGE of CUPS.

KNIGHT of CUPS.

QUEEN of CUPS.

KING of CUPS.

SUIT OF SWORDS

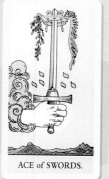
ACE of SWORDS.

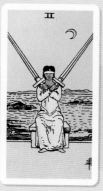

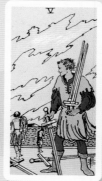

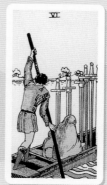

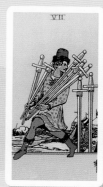

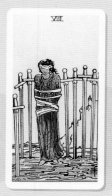

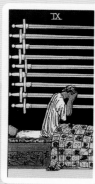

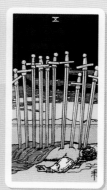

PAGE of SWORDS.

KNIGHT of SWORDS.

QUEEN of SWORDS.

KING of SWORDS.

SUIT OF PENTACLES

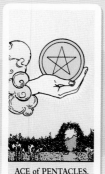
ACE of PENTACLES.

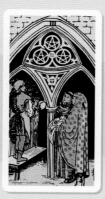

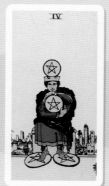

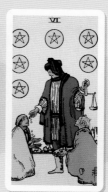

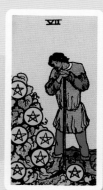

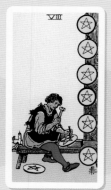

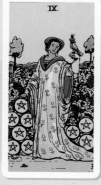

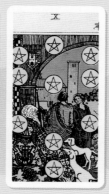

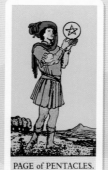
PAGE of PENTACLES.

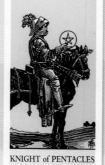
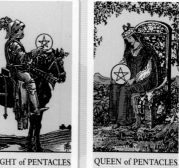
KNIGHT of PENTACLES

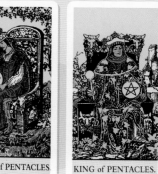
QUEEN of PENTACLES

KING of PENTACLES.

01

02

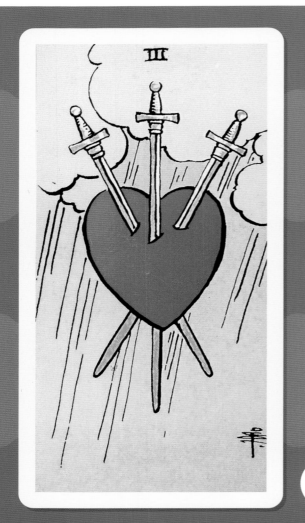

03

04

ALL ABOUT THE CARDS

Within the Minor Arcana are four suits, just like a regular deck of playing cards. Those suits are Wands, Cups, Swords, and Pentacles (sometimes called Coins). Each suit is associated with different facets of our lives.

01. Wands

Work, creativity, passion, and the fire element

02. Cups

Relationships, emotions, and the water element

03. Swords

Conflicts, struggles, thoughts, and the air element

04. Pentacles

Money, resources, values, and the earth element

Major Arcana

The 22 Majors represent our journey through life. Each card is an archetype, rich with symbols, that shows where were are on the path and how we're progressing. There is an element to fate in each card—but that doesn't mean we don't have choices! Even if we encounter The Tower, which signals disruption, we can choose to push back or let go. The Majors show the lessons, but we still have the opportunity to change the unfolding story.

Each suit contains ten cards, plus four figures known as the court cards: Pages, Knights, Queens, and Kings. The court cards can symbolize people in our lives, different facets of ourselves, and a few other things:

01. Pages

Young people, students, messages, beginnings

02. Knights

Young adults, action

03. Queens

Mature adults who identify as female, nurturing

04. Kings

Mature adults who identify as male, leaders, mastery

That's a down-and-dirty guide to what tarot's all about.

Create Your Own Tarot Cards is a beautiful way for you to create a sacred bond with the cards, develop unique interpretations, and imbue it with your own magic. More on that in a bit.

But first, let's talk about some typical tarot myths, some of which you may have heard.

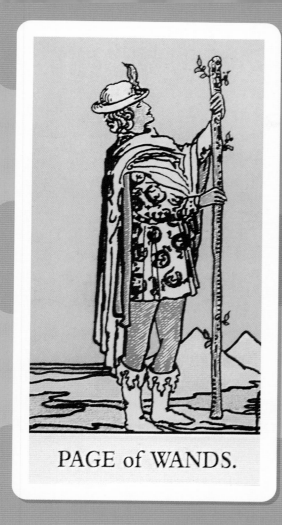

PAGE of WANDS.

01

KNIGHT of CUPS.

02

QUEEN of SWORDS.

03

KING of PENTACLES.

04

TAROT MYTHS & TRUTHS

There are plenty of myths about the tarot. Perhaps you've heard a few.
Let's talk about the most common misconceptions.

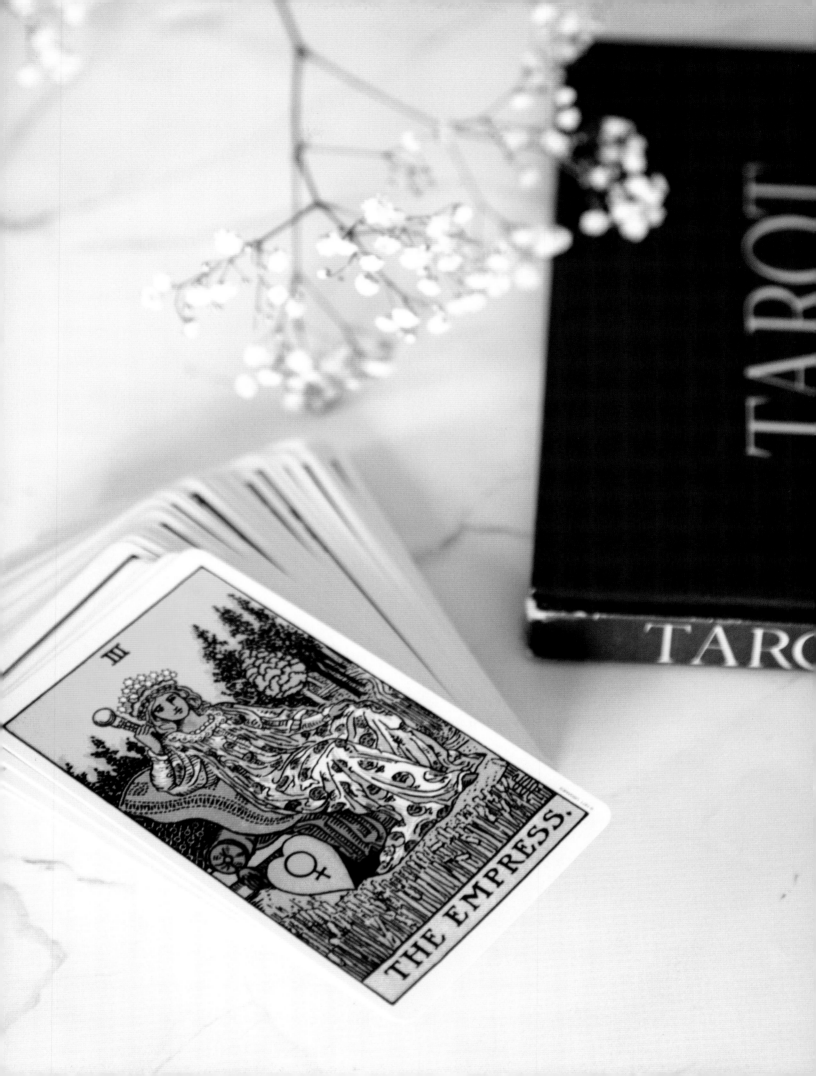

HERE ARE A FEW OF THE MOST COMMON MYTHS. HAVE YOU HEARD OF THESE?

You need to be gifted your first tarot deck.

This is nonsense. If you want to get a deck, there is no reason to wait around. Plus, you're more likely to find one that suits your tastes if you're making the purchase.

The death card means you'll die.

NOPE. We can thank popular culture for this one. The death card is associated with endings and change, not physical death. If you pull this card, chances are you're getting ready for a transformation of sorts!

Intuition is a gift for the select few, and you must be psychic to read tarot.

First, everyone is intuitive. Some people trust their sixth sense a little more than others, making them appear to have some unique ability. You have intuition, and good news: tarot can actually help you access it! The images contain universal symbols and archetypes. As you gaze at the cards, your instincts begin to see the story unfolding. The more you practice with tarot, the easier it is for you to start trusting the stories you're seeing in the cards. Sooner or later, you'll begin to use that same intuition in your day-to-day life.

Tarot is evil or scary.

Tarot is 78 paper cards. That's it.

The cards are neutral. What makes anything good or bad depends on the intention of the user. For example, a match can light a fire in your home and provide warmth. However, that same match can be used to burn down a building. Most tarot readers want to help—and you'll find that tarot works quite well for that goal.

You must read reversed cards (reversals).

This is a matter of preference. Some tarot readers love using reversals, while others can deliver amazing readings without them. It's up to you. There is no "one way" to do tarot. It's best to experiment and find a method that works for you.

Tarot is always accurate.

This is not true. While the cards and your intuition can see many possibilities, the future is malleable. Don't like the outcome? Make different choices. Also, human interpretation isn't infallible. Interpretation mistakes can be made—especially when you're first starting out.

HOW TO CARE FOR TAROT CARDS

It's essential to take good care of your tarot cards—not just physically but also spiritually. These are my favorite tips for keeping your deck safe and clean on both levels.

✦ You'll want to protect your deck from spills and curious hands when not in use. You might choose a special box or bag. A pretty silk scarf is also an excellent choice...plus, you can use it as a reading cloth when you're on the go. Of course, you can also use the box it came in if you prefer.

✦ Before working with your cards, be sure to wash your hands to avoid getting oils or grime on them. This is also a fantastic way to cleanse your energy before you read. If you allow other people to handle your cards, you'll want to encourage them to wash their hands too.

✦ Avoid having liquids or sticky foods around when you're reading tarot. I've seen many decks get ruined from a spilled glass of wine or melted nub of chocolate! Make sure your spot is tidy to avoid trouble.

✦ When you're not working with your tarot, put the cards away in a safe spot.

From time to time, your deck will need a cleansing, especially if you've been reading for a lot of people. There are a few easy ways to remove negative energy and keep your deck clear.

✦ Light your favorite incense and pass the deck through the smoke. This is a fast way to release unwanted vibes.

✦ Put your deck in a window that catches the moon's rays. Leave it there overnight. I usually put a quartz crystal on top of the deck.

✦ Lastly, take the cards and put them in the original order from The Fool all the way to the King of Pentacles. Once you've done this, give them a good shuffle. I swear by this method, which is similar to rebooting your cell phone.

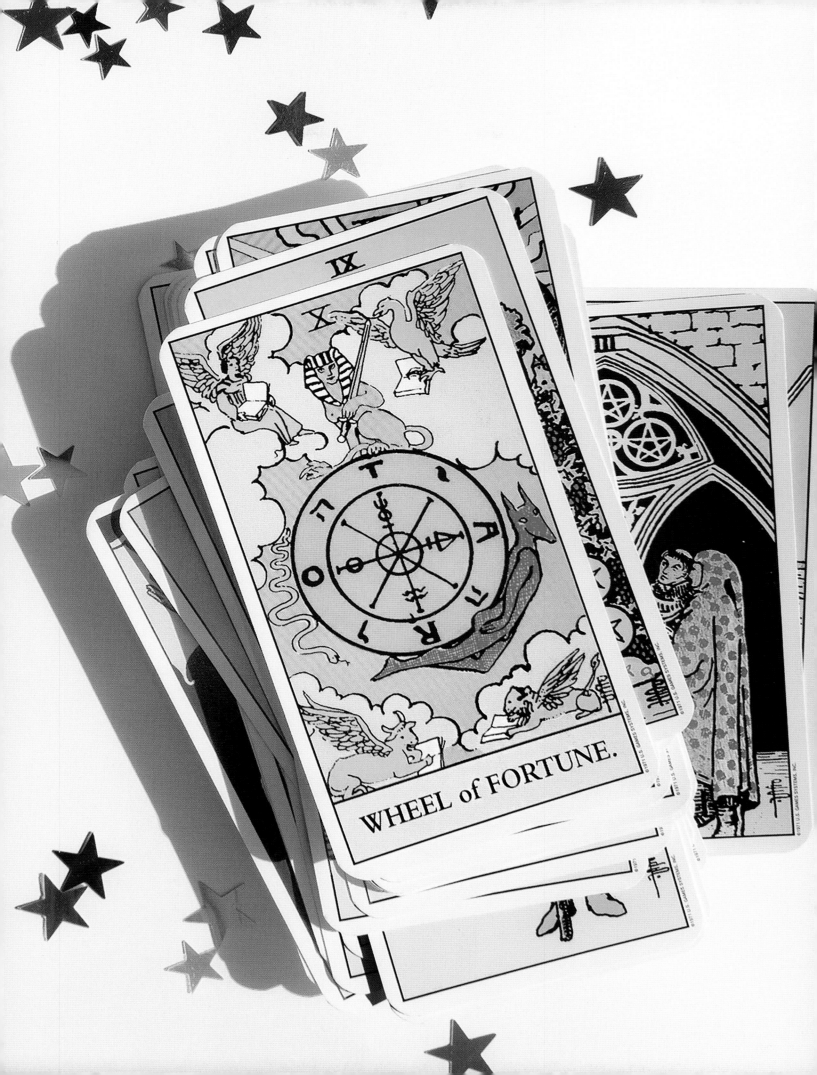

HOW TO DO A TAROT READING

You might be wondering how tarot works...specifically, how to do a reading. It's actually quite simple! You think of a question, shuffle the cards, pull one (or a series of cards), turn them over, and begin interpreting. That's it.

However, although the process isn't complicated, there are a few things to know about delivering or receiving a helpful, empowering tarot reading. First, it begins with a calm, open mind. If you're coming to the tarot table in a panic or with a closed-off attitude, you won't get much out of your reading. Chances are, you'll see what you want, what you fear, or nothing at all. A chill, receptive mindset sets the perfect stage for a great reading.

Next, you'll need to formulate a strong question. Many people assume that tarot will see the future with all the details laid out in a nice, clean storyboard. While tarot cards can predict likely outcomes, the future is rarely set in stone. You do have a say in how things unfold, however. Tarot is not a passive act—and neither is your life. Your choices can turn a situation around...or tank it. Therefore, you'll want to avoid questions that create a fatalistic approach to your future.

For example, a "will this happen" query may give information about what's ahead, but it's not a guarantee. There are plenty of factors that can alter the outcome, including your inaction as you sit around waiting for something to happen.

Instead, a better way to frame a question will go something like this: "What do I need to know about...?" or "How can I...?" When you formulate your questions in this manner, the cards will offer up guidance more aligned with taking control of the wheel rather than being the passenger. After all, this is your journey. Wouldn't you rather know the best way to reach your destination and how to avoid the potholes along the way?

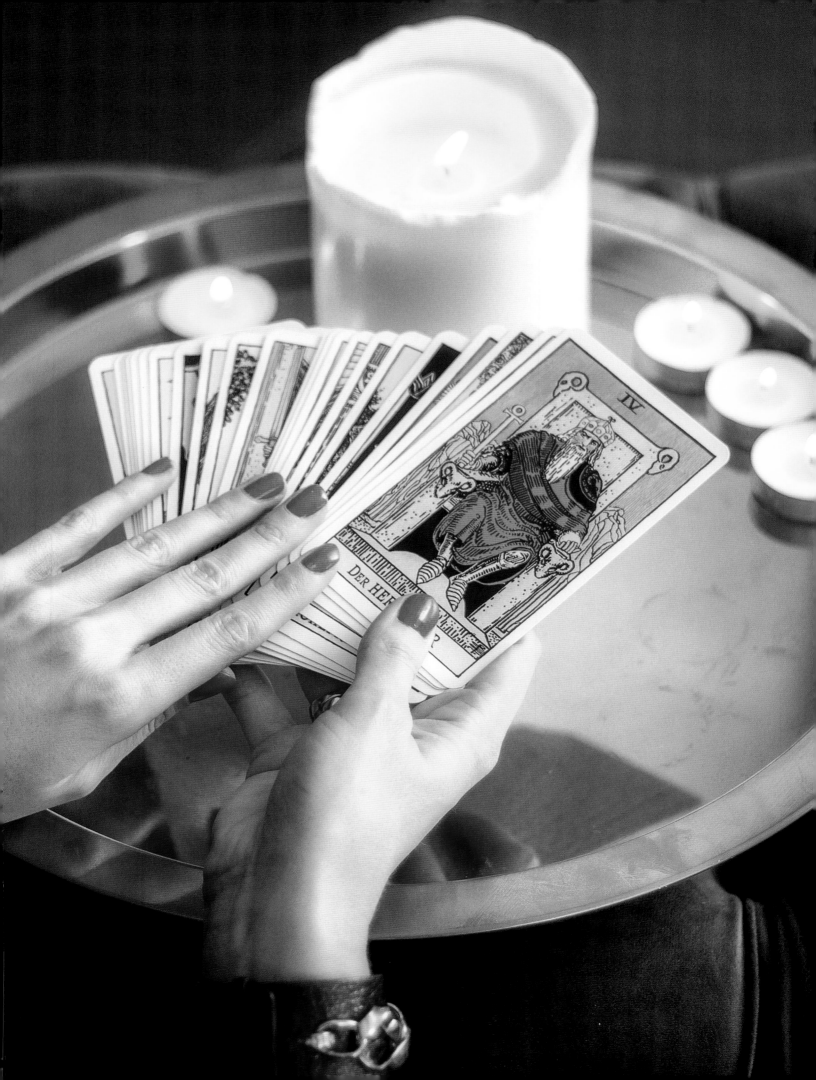

PUTTING IT INTO PRACTICE

If you want to know the outcome of a situation at work, instead of asking, "Will I get the promotion?", try: "What do I need to do to receive a promotion?" The second question can give you helpful information about your circumstances and advice for stacking the odds in your favor. This creates a proactive approach to your life, which allows for conscious living.

So, let's say you have your question. Let's use the one in our example. Before you begin, take a minute to wash your hands. This will prevent greasy fingerprints and other debris from wrecking your deck.

Once you've cleaned your hands, the next step is to shuffle your cards thoroughly while thinking of your question. Shuffling is like a miniature ritual. As you sit quietly, jumbling the cards, you might notice that your mind begins to settle down. Breathe deeply and keep the question on your mind as clearly as you can. Do not fixate on the outcome. Instead, remain as neutral as possible as you continue rearranging the cards. Then, when you feel "ready," put the deck facedown in front of you.

How do you know if it's ready?

You simply know. The cards "feel" like they want to speak to you. Or perhaps you're tired of shuffling them. That boredom can be a sign you've done enough and that you are prepared to throw down and begin interpreting.

With your left hand, divide the deck into three piles. Why the left hand? Frankly, it's an old superstition that goes something like this: Your left hand is closer to your heart. Therefore, the reading will come from the heart. Silly? Perhaps. But sometimes, those old superstitions have a bit of truth to them. I've cut my cards this way since I first had a deck in my hands, and it's always worked out. (I'm left-handed, so maybe there is something to that too.) Feel free to use the other if you don't want to or can't use your left hand. Now, put the deck back together any way you wish.

A Quick Note on Shuffling

If you cannot shuffle the cards for any reason, it's perfectly fine to have a caregiver or friend shuffle and cut for you. This will not impact your reading. What's important is that you have a solid question and are calm.

If you're reading for another person, you might want them to shuffle the cards...or not. This is a personal preference. Some readers feel that the reading will be more accurate if the other person puts their energy on the cards, while others don't want anyone handling their deck. Figure out what makes sense for you—and stick with it. Many professional readers do not offer in-person sessions, which means no one touches their tarot. And guess what? Those readings are just as excellent or even better than face-to-face.

If you decide to allow other people to handle your cards, be sure to ask them to wash their hands first. You'll also want to encourage them to shuffle gently. Taking this precaution will ensure that your deck lasts as long as possible.

LET'S READ!

The cards have been shuffled, cut, and put back together. So, take a deep breath—and let's start interpreting!

You may decide to pull one card or a series of cards, which is called a "spread." One card can deliver a lot of information. Often, it's all you need. However, I'll suggest a few good spreads in a minute.

There are two methods for choosing cards:

- You can take the first card from the top of the deck.
- Or you can fan the cards out facedown and let your intuition determine which one(s) to pull.

Both methods work well. Ultimately, you'll need to determine which feels right.

Once you've chosen the card(s), turn them over and lay them in front of you. Take a minute to scan the images. What are your initial thoughts? Is there a particular symbol in the card that draws you in? How do the colors make you feel? What might the figures say if you had a conversation with them? If you chose more than one card, what story is unfolding, and how are the cards interacting with each other?

Let your intuition begin guiding you to find your interpretation. Of course, you'll want to keep your question in mind as you do. After all, if you pull the Seven of Cups for a romantic question, it will have a different meaning than a business query. The basic meaning of the card may still hold true, but your sixth sense will find interpretations that make sense for the question.

Using our question, "What do I need to do to receive a promotion?", let's try out a few different tarot cards to see what interpretations we might find.

01. Five of Wands

This is a card of competition. There may be other people gunning for this same promotion. If you want to win the coveted spot, you must be willing to give it your all. It's not enough to throw your hat in the ring—you must be ready to fight. A strong effort will allow you to stand out in the crowd. Keep your hustle mighty and you could win big.

02. The Hierophant

First of all, you must be willing to play by the rules. The person in charge is a stickler for policies. This means you don't get to be the rebel; you must fall in line and show that you understand how to operate in this environment. There may be specific rules in place for this particular position. Secondly, you might need to work closely with your boss or mentor to learn the ropes. Be a willing pupil, and you'll be ready to take the reins with confidence. Better yet, your boss will be impressed with your willingness to learn.

03. Page of Cups reversed

You may not be ready for what this job entails. Before you dive in, gather more information. For example, will the hours be longer, and if so, will they cut into your precious family time? What additional duties may come with this promotion? More importantly, why do you want this promotion? Is this aligned with your heart or your pocketbook? Look deeply into the situation before you say yes. You might find this isn't what you thought it would be.

See how different those interpretations are? Now consider for a moment if the question was about finding love. These meanings will change dramatically even while retaining the traditional associations. The Five of Wands could mean putting yourself back into the game; the Hierophant could suggest a matchmaker; and the Page of Cups reversed may warn you not to be emotionally impulsive.

As always, you'll want to examine the card, keep the question in mind, and go from there. But, above all, trust your intuition. It knows what's up and will help you find the proper guidance.

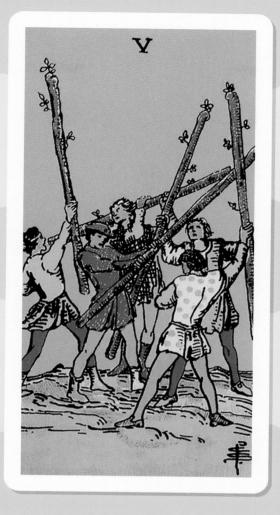

V

01

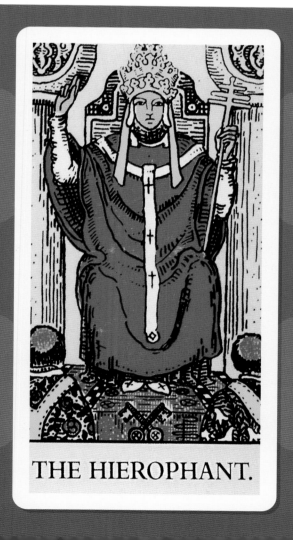

THE HIEROPHANT.

02

PAGE of CUPS.

03

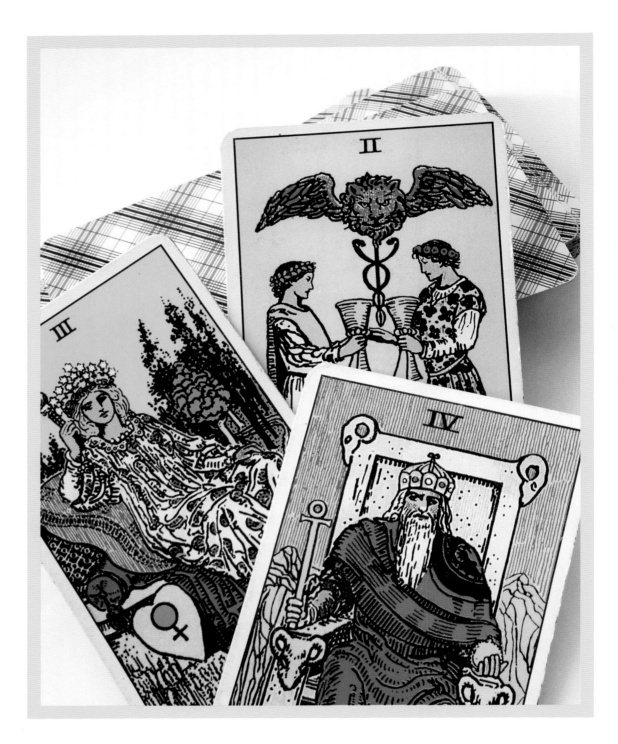

SPREADS

When you choose more than one card, it's called a "spread" or "layout." While one-card readings offer a wealth of information, additional cards allow for a deeper story.

Spreads may have defined positions—or not. If you're working with the latter, your intuition will be the key in determining what the cards are trying to say. On the other hand, a layout with particular positions offers a guideline for the reader.

For example, let's say you choose The Empress, Two of Cups, and Nine of Cups. If there are no positions defined, you can scan the cards and see how the figures interact and perhaps notice patterns such as the presence of two from the Cups suit. It's pretty safe to say this reading is showing a favorable

outcome for romance. Perhaps you're about to meet someone new, and it could be precisely the type of relationship you desire.

Now, let's change this up. If you're doing a spread like the Body, Mind, Spirit, the interpretation has a structure. For example, The Empress for the Body might indicate a healthy, well-cared-for physique. The Two of Cups for Mind would show balance and healing, while the Nine of Cups for Spirit might suggest a happy meditation practice.

You'll need to be clear on whether you want to use a tarot spread or not before you begin shuffling. Here are a few suggested spreads you might try.

Body, Mind, Spirit

This is the perfect spread when you need to check in and see how you're doing. Use this at the beginning of your day or week, or anytime you need to get in touch with your well-being.

Shuffle and cut as usual. Then fan the cards out facedown and use your intuition to pull cards for each position.

Study the images. What clues are they giving you about your body, mind, and spirit? Is it time to level up your self-care or spiritual practices?

Always remember that if you don't like the outcome, you can change course. Here's a spread I use all the time for guidance:

Keep in mind that the Body, Mind, Spirit spread is for introspection. It should never be a substitute for medical or psychological advice. Always consult the proper licensed professionals if you are currently dealing with an issue.

Past, Present, Future

This simple tarot spread can help you see where you've been, where you are, and where you might be going next. You can use this when you want a glimpse into the future.

For this spread, you can choose to take the cards from the top of the deck or fan them out and choose consciously. Either way works fine.

Read the cards from left to right as if you are telling a story with a beginning, a middle, and an end.

Always remember that if you don't like the outcome, you can change course. Here's a spread I use all the time for guidance:

The Situation: What You Need to Know & Advice

The beauty of this layout is the second position—what you need to know. This may reveal something you're not seeing, and that information can be beneficial. The advice position also offers up guidance, which puts you firmly in the driver's seat.

Once again, follow the typical shuffle-and-cut routine. Choose the cards from the top of the pile. Turn them over one by one, interpreting as you go. Pay close attention to "what you need to know" before you consider the advice card. Together, they'll give you useable wisdom—and it may not be what you expect.

With these three spreads and one-card pulls, you have everything you need for practical, accurate tarot readings.

Of course, there are many spreads you may want to try out, such as the famous Celtic Cross. I recommend testing out as many as possible. You might even want to try to create some of your own spreads. I've done this myself, but frankly, I always end up coming right back to the readings suggested in this book.

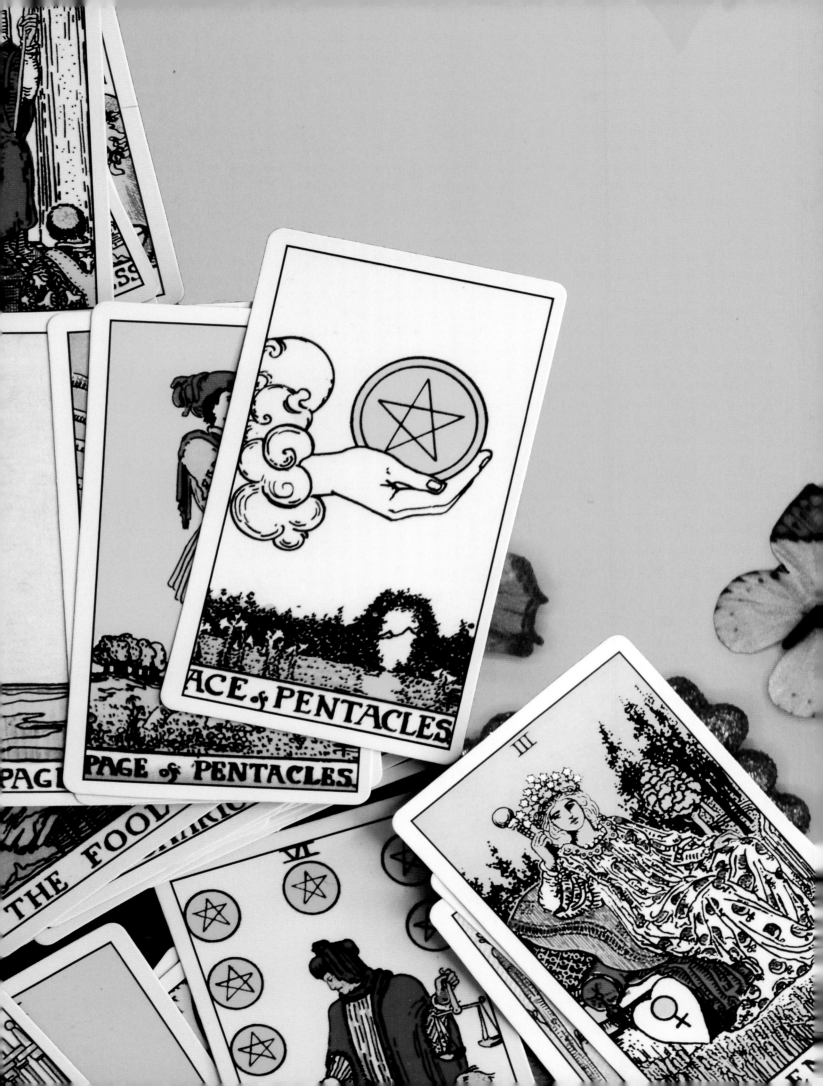

COMMON TAROT READING ISSUES—AND HOW TO TROUBLESHOOT

When you begin learning tarot, you may have a lot of questions about the process. However, you might be surprised to know many longtime readers also have some of the same concerns. Here are a few of the most frequently asked questions—and my advice.

Q: I'm worried the reading will be wrong. How can I be as accurate as possible?

A: Here's the deal. You will be wrong at times, especially when you're first starting out. That's how you learn. One of the things I've discovered over the years is that the cards are usually right on, and problems with accuracy often center around misinterpretation. This is why I recommend recording your readings in a tarot journal. As you look back at botched readings, you'll be able to see where you missed the mark. Your tarot journal will give you all the information you need to start seeing where you went wrong and what direction might have been better. And those butterflies you're feeling? They never go away. That's not a bad thing. It's a sign you care enough to want to do a good job. I've been reading tarot for 40 years, and I've never lost that little twinge inside before I sit down to read.

Q: Do I need to learn the meanings? Can't I just go with what I see in the cards?

A: Ultimately, you'll want to find a balance between the two. A solid foundation of knowledge will give you something to work with, and that builds tarot confidence. But, of course, your intuition will have a say in how you interpret those cards. If you're getting a gut feeling, go with it, even if it seems out of place. Often, those flashes of intuition turn out to be accurate—and it's cool when you get a psychic hit! In time, you'll rely on the books less and less, and your instincts will uncover new meanings and depth to the cards. The more you work with them, the more you'll learn to trust your sixth sense.

Q: What do I do if I draw a blank?

A: This happens to every reader, even seasoned pros!

First, take a deep breath. Next, scan the images and see what catches your eye. Is there a symbol that seems to stand out? If so, use that as a jumping-off point. If you still aren't getting anything, start describing the card. When you do this, the story will begin to unfold, and you'll find your interpretation. This is a technique many readers use—and it always seems to work. Of course, there may be times when no information is coming through, no matter how hard you try. When that happens, write down the cards and leave them alone for a day. Then revisit the reading at a later time. You might find the answer was more apparent than you thought!

Q: What does it mean if I get all reversals?

A: If your reading consists of nothing but reversed cards, it is a sign that something is blocked and you may need to look within...or give it time to manifest.

Q: My prediction didn't come true. What am I doing wrong?

A: Often when a reading doesn't work out, it's due to misinterpretation. The cards can have different meanings, and if you review them later, you may see where you might have interpreted them differently. Keep in mind that no one is infallible and not every situation is clear. Sometimes you're just not meant to know.

Q: Are there any questions I shouldn't ask?

A: Trying to pry into other people's lives is a no-no. Tarot is not for spying. Asking about situations that are none of your business? Nope. Don't do that. It's also unrealistic to ask the cards how someone feels about you. They aren't a mind-reading tool. Lastly, you never want to ask questions that should be directed toward your doctor, lawyer, or therapist. Tarot is never a substitute for professional help.

Q: When shouldn't I ask a question?

A: If you're overly invested in the outcome, feeling freaked out, or impaired in any way, you'll want to leave the cards alone. Your state of mind is essential. The best readings happen when you're calm, clearheaded, and sober.

Q: What if I don't like the outcome?

A: If you do not like the story the cards are showing, you can always pick a clarifying card for guidance. This may add additional insights or offer a detour. That being said, do not keep pulling cards just to get the outcome you desire. Life doesn't always go the way you want...and neither does tarot.

WHY IT'S COOL TO PAINT YOUR OWN TAROT DECK

So now we've gotten to the end of this Little White Book, and you're now ready to paint your tarot deck! Yay! Here are a few reasons why it's awesome to paint your cards.

The Little White Book, or LWB, comes with most decks of tarot cards and includes descriptions of each card in the deck.

 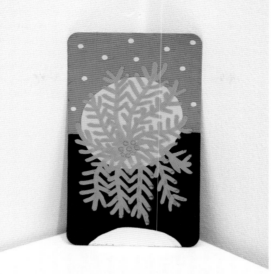 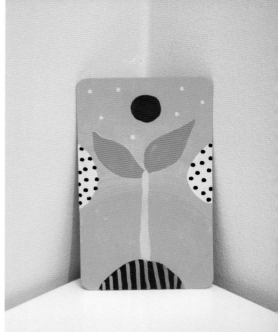

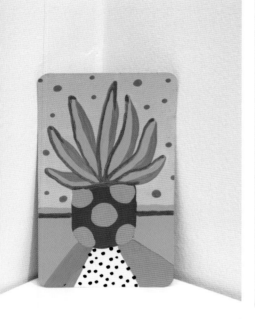 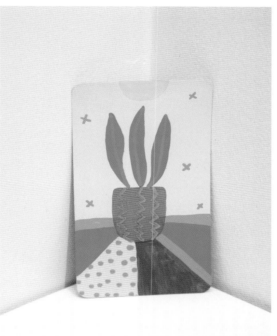 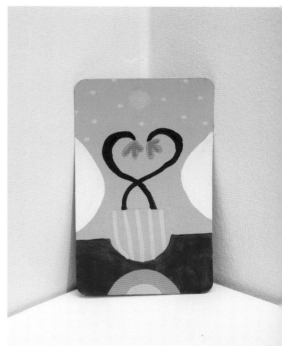

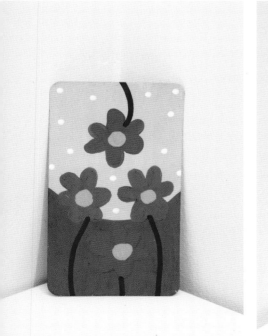 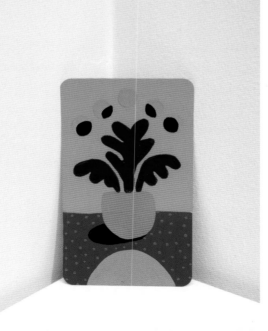 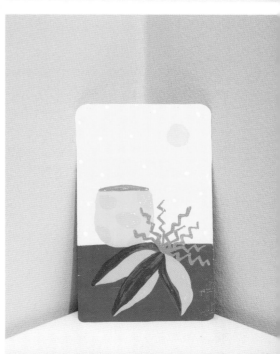

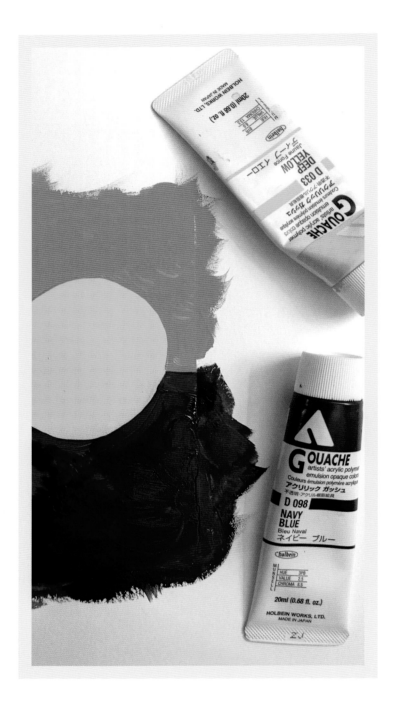

You get to choose the colors you want.

You may prefer vivid magenta and neon green, or something more neutral. The colors you pick will impact how you feel about the deck, as well as how you interpret the cards. Why not incorporate all your favorite colors?

You can make the deck unique to suit your tastes and personality.

For example, your cards may be filled with white space, or every single spot may be dotted with symbols, dashes, and little squiggles. You might like glitter paint for texture. Maybe you want to trim the borders. It's all good—and it's all you. Your deck won't look like anyone else's. That's so special (like you!).

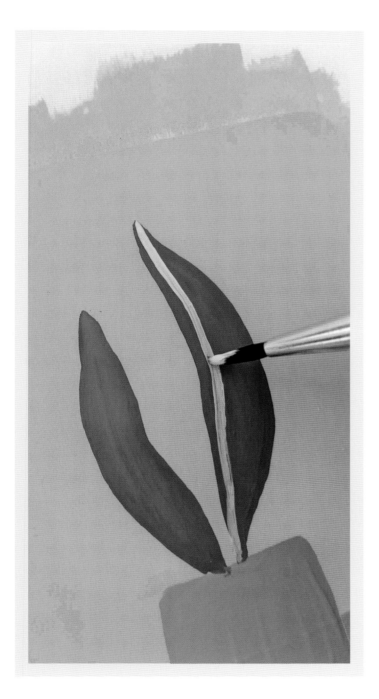

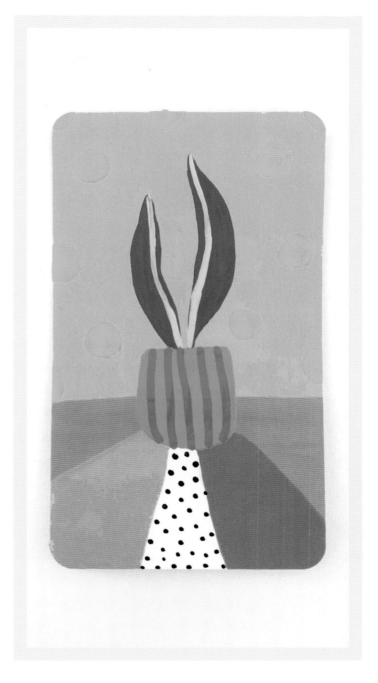

Painting is meditative and a great way to go deep into tarot's imagery.

The ritual of dipping your brush into the paint well and slowly swirling it over the illustrations starts to lull your mind into a state of relaxation. As your mind begins to settle, something remarkable happens: You begin to see things in the cards you might not have noticed before. Different symbols capture your imagination, and suddenly, you're discovering new ways to look at the cards. The more time you spend painting, the deeper your understanding will be.

The whole process allows for a personal, profound connection with your tarot deck.

You're not just making it your own; you're also imbuing your cards with your magic. And that leads to the best readings.

So get out your brushes and go buck wild! Choose all the colors! Let your intuition run free! See what unfolds as you paint, and later on, as you shuffle. Above all, enjoy your tarot journey.

HOW TO PAINT TAROT CARDS

BY ADRIANNE HAWTHORNE
of Ponnopozz

INTRODUCTION

Hi! I'm Adrianne, and I'm a Chicago-based abstract artist who loves color. I was introduced to the tarot informally through my sister—she gave me my first deck for Christmas in 2018. I had never owned a deck before and was excited to get to know the cards. Since then, I've used my deck as a mental health tool. If I can't make a decision or am feeling like I need guidance, I turn to my deck and see what happens.

I don't consider myself a professional at card interpretation, but I've learned what all of the cards symbolize and can usually get a gut reaction when I see them during a personal reading. Above all, I've learned that my intuition is the root of my relationship with the tarot. I've never been good at listening to my intuition, but through tarot, I've learned to listen more closely and not second guess what I feel deep inside. It's been a wonderful tool—one that I continue to practice with today.

In 2020, I decided to combine my love for tarot with my passion for art. I set out to create my very own deck—78 original paintings that will (someday soon) become a real deck of cards. I typically paint abstracted plant forms in my work, so I knew that I wanted the deck to be plant-themed. And it had to be colorful! I wanted to create a deck that represented me, something that hadn't been done before.

My plant-inspired tarot deck is a work in progress as of today's writing. But I know how fun and fulfilling it is to create your own cards. You can truly express yourself this way and it makes your tarot experience much more personal. I'm excited to help you create your own deck, guided by your intuition, style, and personality. Join me—it will be fun!

THEME FOR YOUR DECK

The first step in designing your own tarot deck is deciding your deck's theme. This can be anything you want—which I know doesn't make the decision any easier—but I'll give you some parameters to help you choose.

You will need 78 cards for a full deck, so try to pick a theme that offers a wide enough range of subject matter. Flowers, animals, cars, candy, cocktails...these are all subjects that can take on a range of looks for each card. Some cards are positive while others are dark, so consider how you might depict your subject matter to reflect the card's meaning. Choosing a theme that offers variety will help when it comes time to plan your deck and its suits.

If you would rather use traditional imagery, but drawn in your own style, you certainly can! The Rider-Waite deck, created in 1909, is one of the most popular out there and typically referenced in tarot readings. It's easy to find the Rider-Waite imagery online, or you can purchase a deck for reference as you create your cards.

I chose to use plants for my deck because I love them and already use them in my work.

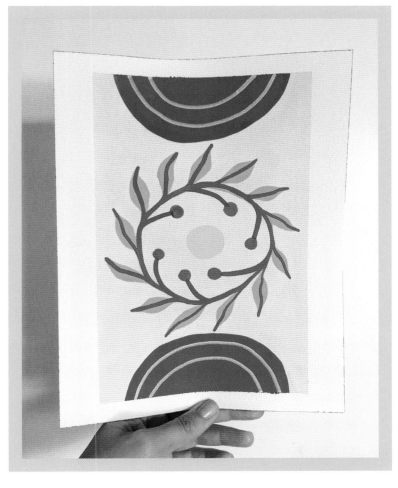

I wanted to make sure my deck had a similar style to my abstract paintings. Also, there are many types of plants, making them an excellent source of inspiration for the various meanings in tarot cards. Plus, I knew I wouldn't run out of plants to paint!

Choosing a theme is really important, so take your time. If you're struggling to come up with an idea, take a look at your favorite books, Pinterest, or nature for inspiration. Free write or journal whatever pops into your head. Almost anything can work as a theme as long as there is enough variety for the cards. If you have a strong intuition about what your deck should be, don't second guess it. If there's anything I've learned about designing a tarot deck, it's that your intuition—and the cards themselves—will guide you. Your intuition is a powerful tool—listen to it!

A Note on Style

If you are struggling to choose a theme, that's OK—your style will tie the deck together. Having a theme can help set the tone of a deck, but you don't need one if you don't want one. Color, illustration style, use of pattern and texture...these are all stylistic choices that will make your deck look like a unit and be something that feels uniquely you. This is a valid direction to take, so if your intuition is guiding you to create each card on a whim, then go for it!

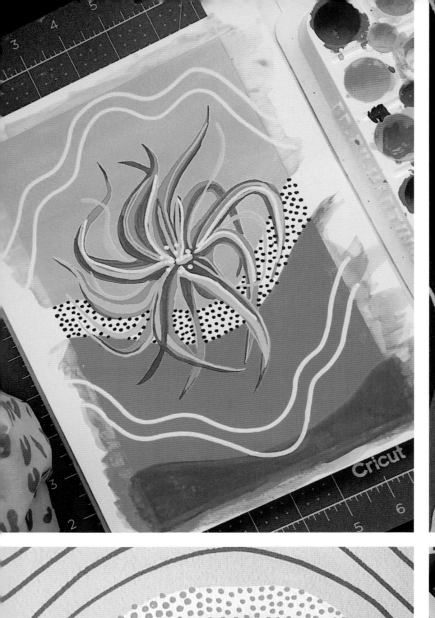
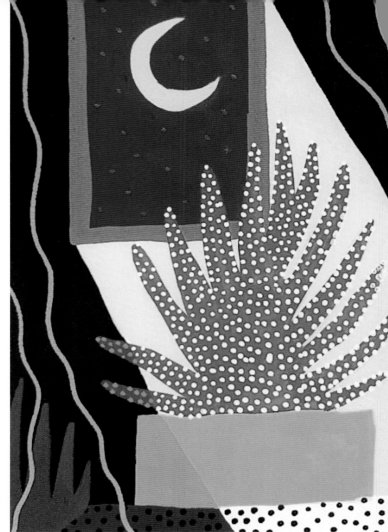
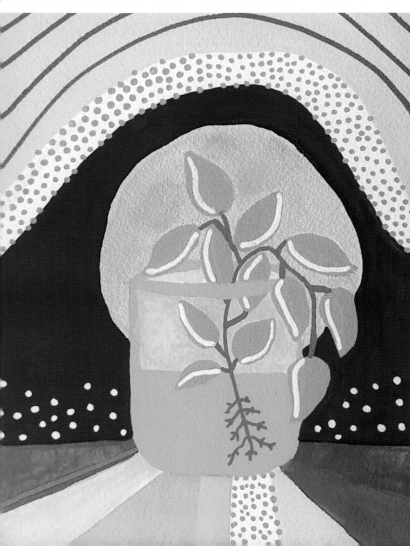
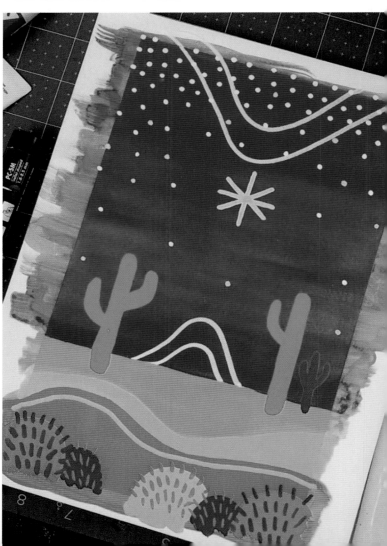

MAJOR & MINOR ARCANA

Once you've decided on a theme, the next step is to choose your suits, and then your court cards. Tarot decks are divided into two sections: the Major and Minor Arcana. The Minor Arcana are the suit cards. Tarot decks have four suits, and they are:

- Wands
- Cups
- Swords
- Pentacles (or Coins)

Each suit represents a different set of feelings and things. The cards range in number from ace to ten, in addition to four court cards. The court cards include the Page, Knight, Queen, and King for each suit. Think about a plan for your deck's cards, using your chosen theme. I'll explain my thought process using plants, which is my chosen theme.

01. Wands

I've decided to riff on the traditional suits by making them plant-related. For Wands, instead of a wand, I've used a made-up plant shape that is thin and sticklike. It's visually similar to a wand but still a funky, fun plant shape that I've created to fit the vibe of my deck. The Wands suit is about creativity, so inventing my own shape for this suit seems appropriate.

02. Cups

The Cups suit is about emotion. To me, a daisy represents emotion because flowers are typically given to others during times of celebration and sadness. Daisies fit within my theme of plants. Their round shape also mimics the top of a cup.

03. Swords

The Swords suit is about action. I've used a thin, fernlike plant with lots of fronds to convey a feeling of sharpness, like the tip of a sword.

04. Pentacles

And lastly, the suit of Pentacles, which is usually about the home, wealth, or other physical possessions. I've created a flowerlike shape that looks like a hand for this suit. The hand shape conveys possessions, or something you can hold in your hand. This suit is also called Coins, so you can choose to depict whichever one you like best.

Major Arcana

The Minor Arcana follows your deck's chosen theme in a precise way. Imagery is chosen in advance for the suits and court cards. The Major Arcana is different.

Rather than representing a specific suit and number, the Major Arcana cards represent individual life themes—things like strength, death, turmoil, and triumph. They are all unique and symbolize different aspects of the human condition. Because of this, they don't need to follow a specific script.

My deck is plant-themed and because of this, I want the Major Arcana cards to all be plants. But for these cards, I've chosen plants based on the overall theme of the card. Painting the Major Arcana is much less restrictive than the Minor Arcana.

My typical process for painting a Major Arcana card involves reading a bit about the card's meaning and journaling about what it means to me in my own life.

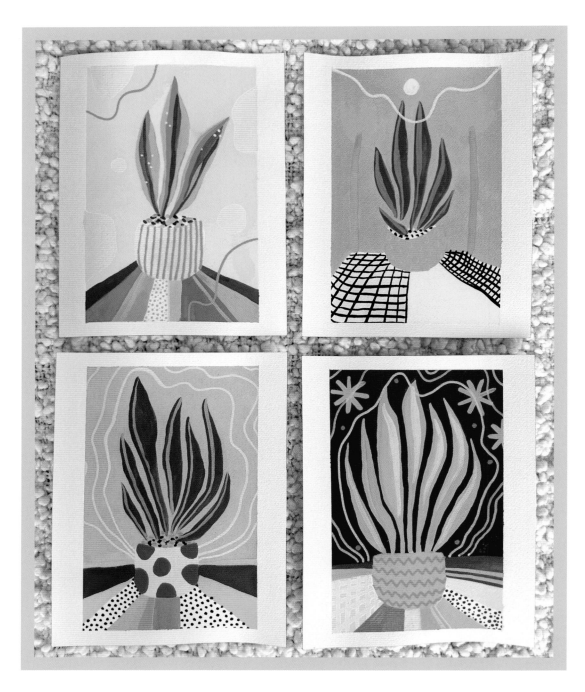

Court Cards

Keep in mind that your suits can be anything—there are no rules here! To keep it simple, you can also use traditional images for wands, cups, swords, and pentacles or coins. Once you've decided on the images for your four suits, you are ready to move on to the court cards.

Each suit has four court cards that loosely symbolize different things. The Page is the least mature of the court cards and usually represents a younger being trying to figure themself out. They may have a few lessons to learn on their journey. The Knight is a little more mature, followed by the wise Queen and most mature King. I've chosen to represent the court cards with potted plants at various stages in their growth.

In the example above, the Page of Pentacles is on the upper left and is represented by a young snake plant. I use a bright-yellow color to convey immaturity and youth. The Knight of Pentacles is the second-youngest plant, shown here in the upper-right corner. It has a bit more growth and has aged more than the Page. The Queen of Pentacles (bottom left) has much more wisdom, so I've made this plant larger. I've opted for a rose-pink background to evoke a feeling of calm and wisdom. Last is the King of Pentacles (bottom right)—the largest snake plant of the Pentacles court cards.

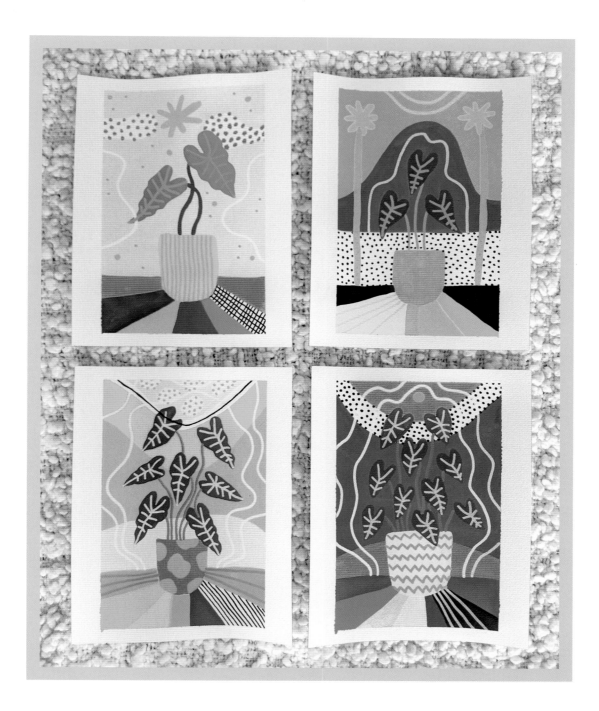

I like using plant maturity to represent these cards. I think it's easy for people to understand quickly. I also make sure to choose a specific plant for each suit's court cards. You don't have to do this, but I want to add one more level of consistency and detail.

I've chosen the following plants for each suit's court cards:

- Wands: Banana plant
- Cups: Monstera plant
- Swords: Alocasia plant
- Pentacles: Snake plant

These plants are all distinct from one another and loosely represent the suit to which they belong. Banana plants are long and thin (like Wands), monstera plants are warm and friendly-feeling (like the emotional Cups suit), alocasia plants have a sharp point (like Swords, which are about thoughts, conflict, and action), and snake plants are consistent and even (like Pentacles and the feeling of home). Feel free to do the same when you choose a subject for your court cards—but remember that you don't have to do it exactly this way.

SKETCHING & INSPIRATION

Once you've planned out your deck's theme, suit, and court cards, you can begin your deck! I find that I don't like to go right to the final product, so I usually spend some time sketching and looking through books for inspiration. My go-to book for this project is called *Leaf Supply: A Guide to Keeping Happy House Plants* by Lauren Camilleri and Sophia Kaplan (Smith Street Books). I chose this book because it has beautiful images of all types of plants, and it was very helpful when deciding my suit and court cards.

Deciding which card to paint can also be a fun process. Feel free to choose the card that speaks to you. In my case, I want to leave it up to chance, so pick a card at random from the deck my sister gave me. The card I pull is the card I paint.

Sometimes after I pull a card, I have an idea right away and begin sketching. Other times, I reference *Leaf Supply* or the plants in my own home for inspiration. Sketching is a powerful tool. It allows me to visualize a card before creating the final product. It also lets me try out different color combinations before settling on the final. Take as much time as you need in the sketching phase; it's important to feel good about the card you're going to make.

In some rare cases, I skip sketching altogether because the image I want to paint comes to me immediately. This is OK too! Begin the final card when you feel ready—there's no right or wrong way to approach the creative process.

One thing I like to remind myself is that nothing is ever final. As you paint your card, if something isn't working, feel free to start over. In some cases, you can paint over or erase what you don't like. Change the card until you like it. Just because you put brush to paper doesn't mean the card cannot be changed.

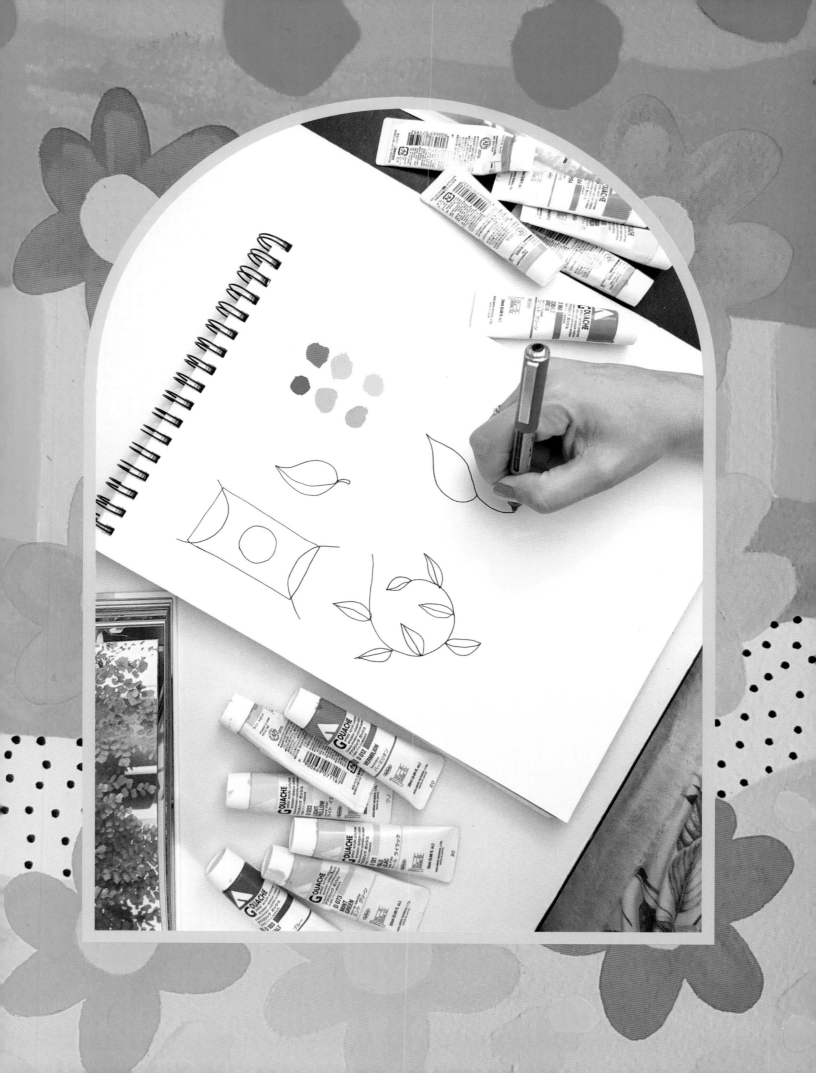

TOOLS & MATERIALS

In this book, I've used Holbein® Acryla Gouache for my cards. I love gouache because it gives good coverage like acrylic, but it can be thinned to look like watercolor. It holds well to paper and lasts a long time. Plus, the colors are so vibrant! Since I'm a painter, I wanted my deck to also be painted, but you can draw yours if you prefer.

If you want to follow along with me, here are the supplies you'll need:

- Gouache (any brand and as many colors as you like. It's a good idea to have a nice mix of light and dark colors for this project.)
- Paintbrushes of any kind; they don't have to be expensive or fancy
- Jar for water
- Artist's tape (This is important! Other tapes, like masking or painter's tape, can damage the paper. Investing in artist's tape is strongly recommended.)

- Card-stock tarot cards (included), or you can use watercolor paper
- Markers or paint pens (I use POSCA® paint markers and Sharpie® permanent markers)
- Optional: table fan to speed up drying times
- Optional: Scotch® clear packing tape or a laminator
- Optional: Spray varnish in matte, satin, or gloss finish
- Optional: Mask for spraying varnish

A Note on Longevity

Your cards should last a long time if you're careful when you use them and store them in a safe place, away from water, sunlight, and extreme temperatures. To ensure extra longevity, you can laminate your cards or use clear packing tape to cover the painted surface. Both options will add thickness and durability to your deck.

You can also coat your cards in a clear varnish. Varnish is easy to use and will protect the paint on your cards, but the chemical smell can be strong. It fades over time, but if you are sensitive to chemical smells, this may not be for you. A gas mask can be used during spraying. Invest in the method that you prefer (or none at all!).

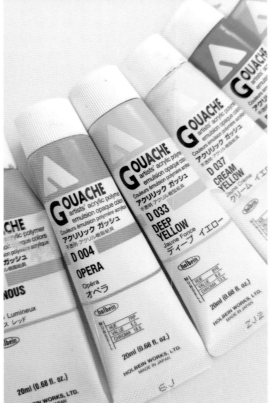

THE FOOL

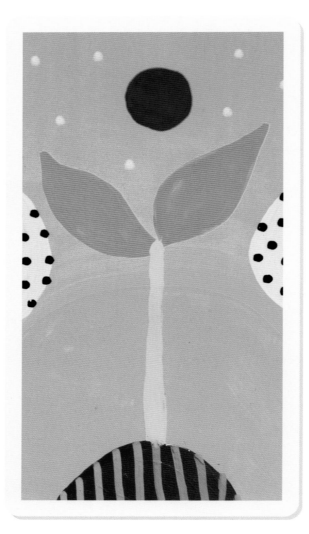

The Fool is a card of new beginnings and youthful energy. It's the beginning of a new adventure or chapter. There's excitement around what's to be, and not much of a focus on what could go wrong. In a reading, The Fool card invites you to take a leap of faith. Go after your dreams, even if you don't feel ready. The first step is often the hardest.

COLOR SCHEME

Step 1: Sketch

Sketching is optional, but it's something I like to do to orient my mind and plan out what I want the final card to look like. Grab some scrap paper, pencils, and paint (or whatever you'll use to create your card).

Read about The Fool card and think about what it means. Write down a few key words to help guide you. Since The Fool card is about youthful innocence, I want bright, playful colors and I've tested several colors on the far corner of my scrap paper.

Next, doodle some ideas. A cutting and a seedling are the ideas that emerge first for me, and I like the composition of the seedling direction. I decide to move forward with a seedling as my final card imagery.

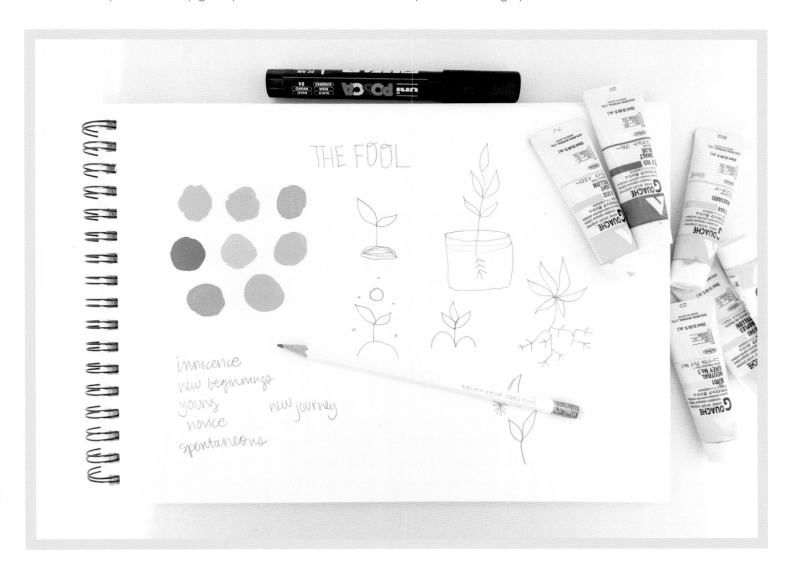

Step 2: Prep

Now it's time to prep your card for painting! Note that taping off the back of the cards is optional. If you want the back of your cards to stay neat, use artist's tape to tape off the edges so paint doesn't get on them. It's important to use artist's tape because it won't damage the paper card. Use scissors to trim the excess and flip your card over.

If you don't mind if the back of the cards get a little paint on them, feel free to jump to this part of the process. Use artist's tape to tape the blank card to a sheet of scrap paper. If you taped off your card edges, flip the card over so the blank side is facing up.

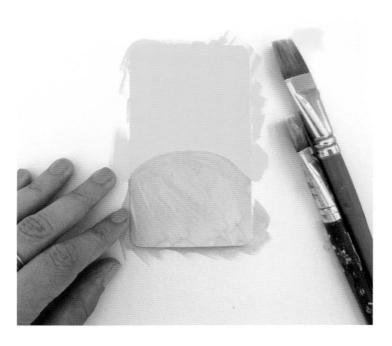
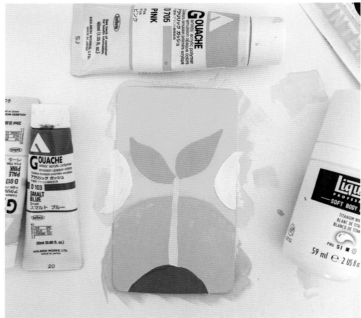

Step 3: Paint the Background

Next, you'll paint your card's background. Take the paint all the way to the edge of the card and use wide swaths of color. I try to keep my backgrounds simple so that my foreground imagery stands out. Let the background dry before moving on to the next step, and add a second coat of paint if you feel like the card needs it (I've done this).

Step 4: Paint the Foreground

Here's where sketching comes in handy. I reference my doodles for the seedling and paint two small leaves. Next, add the seedling's stem, a dark semicircle for the stem to anchor to, and two white spots that you'll add a pattern to at the end. Let the foreground dry before moving on to the next step.

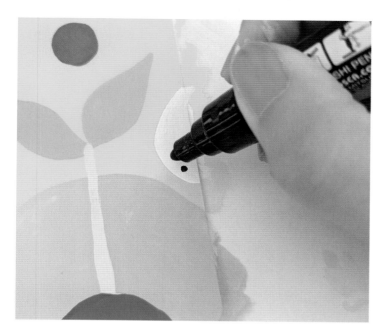

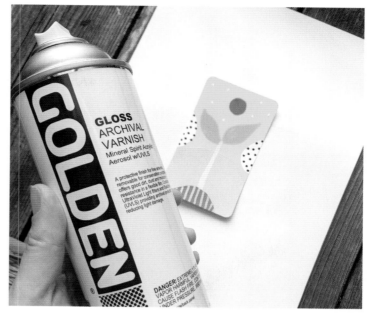

Step 5: Add Finishing Touches

This is my favorite step! Adding small, final details really brings a tarot card to life. In this case, I use a paint marker to add black dots to the white areas painted earlier. Next, add light pink stripes to the deep-blue semicircle. Last, add a sun above the seedling and small white dots in the yellow sky. Let the paint dry completely before removing the card from the scrap paper.

Step 6: Varnish (optional)

Spray varnish protects the paint on your cards from wear and tear, but it's completely optional. If you don't want to add varnish, simply remove the artist's tape from your card and you're finished!

If you do choose to apply varnish, make sure all the artist's tape is removed from your card and that your card is completely dry. Wear a mask and spray in a well-ventilated area. Place your card on a piece of scrap paper before spraying. Shake the can of varnish well and spray about 8 inches from the card. Coat evenly and let dry before bringing the card inside (varnish has a very strong smell)!

I use GOLDEN® brand spray varnish with a glossy finish. Matte and satin finishes are also available and work equally well. The finish is a personal preference and totally up to you!

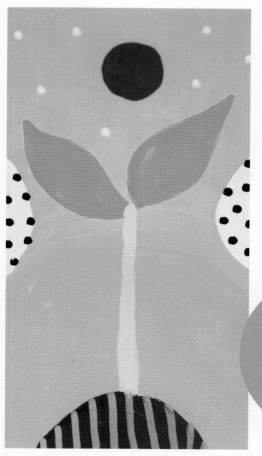

Once your card dries, you are finished! On to the next card!

DEATH

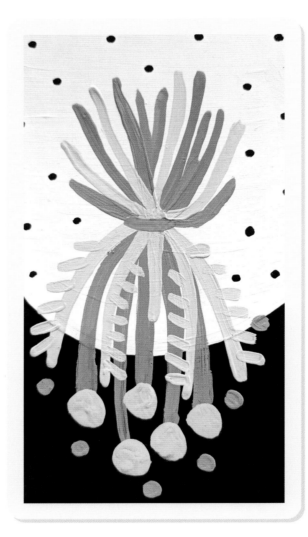

The Death card is part of the Major Arcana, and it can be a scary card to see in a reading. But remember that the Death card isn't always negative. In fact, it typically symbolizes a part of you or a situation that is dying, rather than literal death. It can be about transformation and rebirth too.

· DEATH ·

COLOR SCHEME

Step 1: Sketch & Prep

Since the Death card isn't necessarily about the end of life, I want to avoid imagery of dead plants fallen over in pots. This is especially clear once I start sketching. Instead, I want to focus on the beauty that can come from change. I've decided to create an upside-down bouquet of dried flowers. While once vibrant and alive, dried flowers are still beautiful in their second life. Since the concept of death is often dark, I decide to stick with a muted color palette consisting of black, light gray, and shades of yellow and olive.

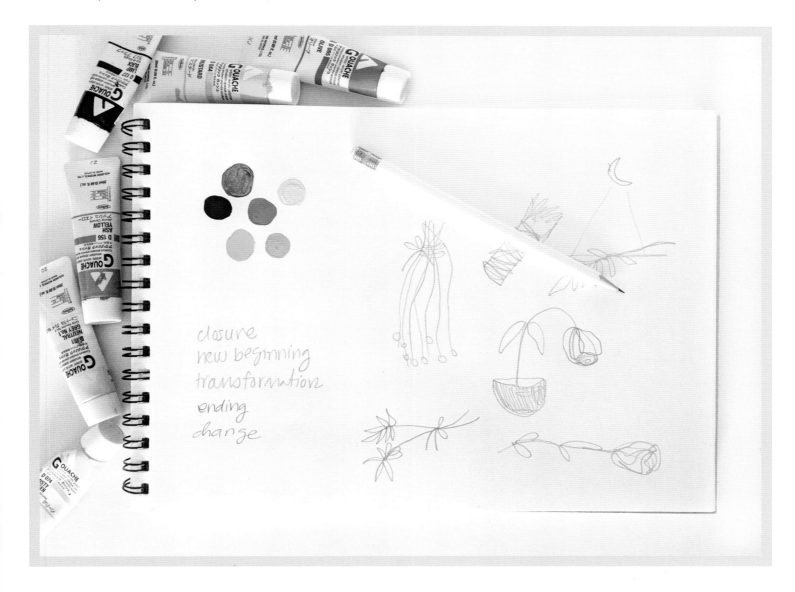

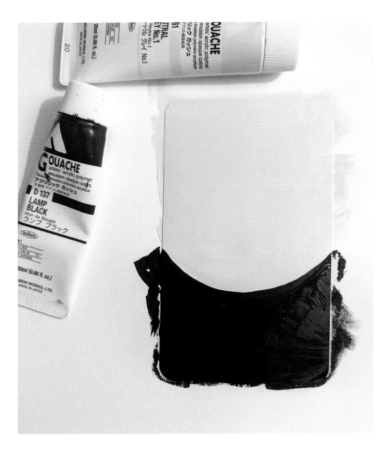

Step 2: Paint the Background

Begin by painting the top two-thirds of the card with a light, neutral gray. Add black to the bottom third for a dramatic effect. It's important when using dark colors—like black or navy—to let the background dry completely, so you don't get dark smears over lighter foreground colors.

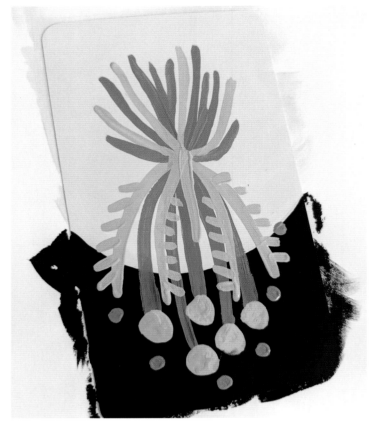

Step 3: Paint the Foreground

Once the background dries, you can get to work painting the stems of the dried bouquet. I've used an olive green for this, and I've added round flowers to the ends using mustard yellow.

Next, add a few more stems using a light misty green, and finish with dots in ash yellow. I like the contrast of the yellow flowers against the leafier green stems. I think it adds interest against the dark background.

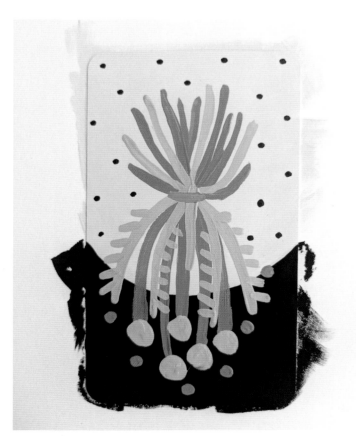

Step 4: Add the Finishing Touches

For the details step, I've decided to use a black paint marker to add stars to the sky. To conclude the card, I do something a bit unexpected and add a red-orange tie to the bouquet. This color was not in my original plan, but something about it feels right. By now, you know not to ignore your instinct with the tarot!

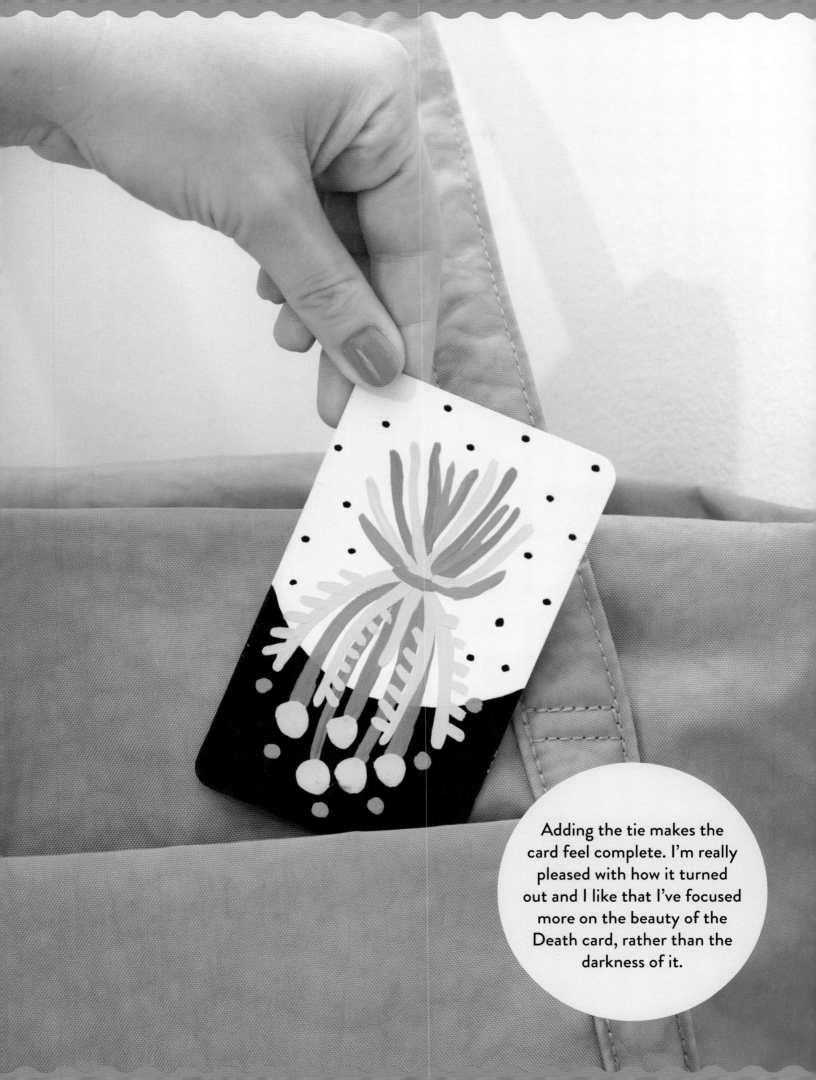

Adding the tie makes the card feel complete. I'm really pleased with how it turned out and I like that I've focused more on the beauty of the Death card, rather than the darkness of it.

THE EMPRESS

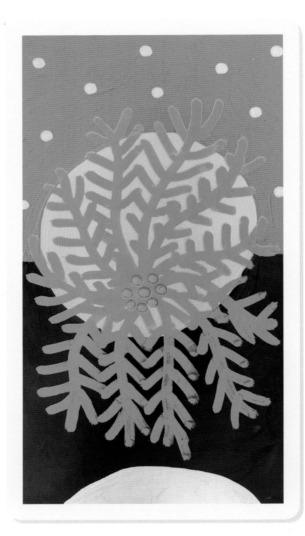

The Empress is part of the Major Arcana. A card that represents warm, female energy, it is nurturing and sometimes suggests to the viewer that it's time to reconnect with nature.

COLOR SCHEME

Step 1: Sketch

For some reason, when I think of motherly energy and plants, a fern comes to mind. I have no idea why this is, but I've learned not to question my initial thoughts when it comes to painting the tarot. Those initial thoughts are really your intuition, and you should follow it for something as intuitive as tarot cards!

Ferns are large, dominant plants that still feel soft and welcoming. The Empress has been described as the mother of the tarot, so to me, this plant fits perfectly. I've sketched two types of ferns; I'll decide which style to use later in the process.

Tape off your card's back (if you are doing that) and adhere it to a piece of scratch paper for painting.

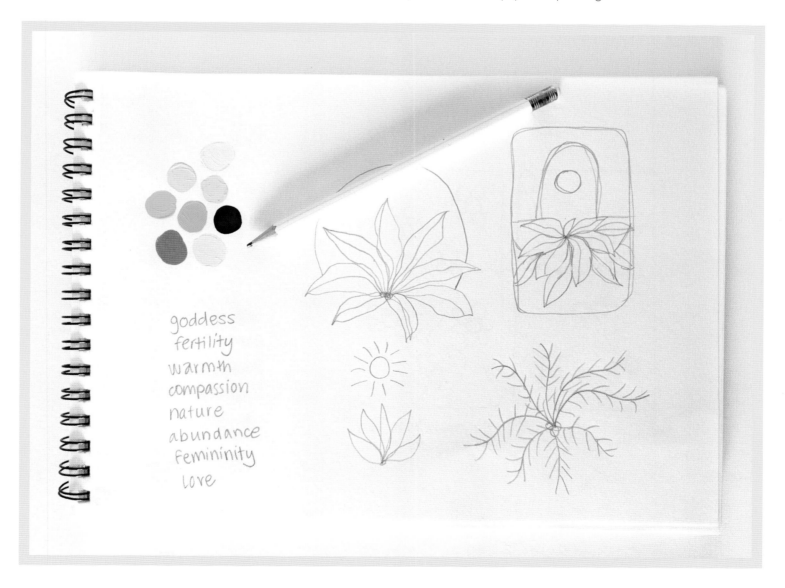

goddess
fertility
warmth
compassion
nature
abundance
femininity
love

Step 2: Paint the Background

I want to project warmth with this card, so I've painted a yellow sun in the background. Next, add warm red and indigo color washes to either side of the sun. I've decided to stick with a primary color palette for this card because I like the vibrancy and I think it fits perfectly with the meaning of The Empress card.

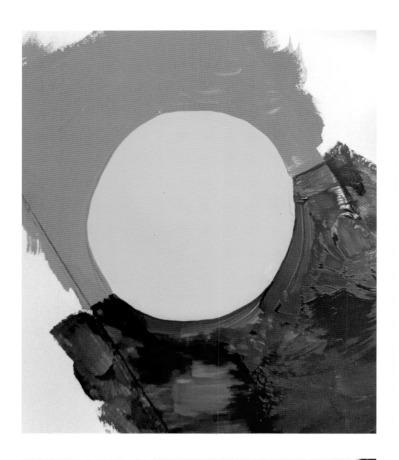

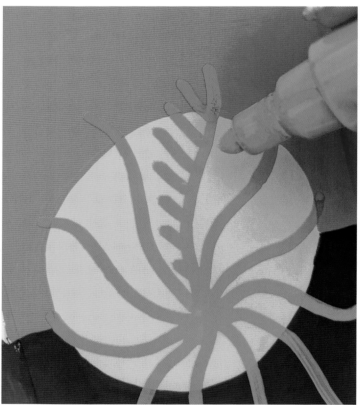

Step 3: Paint the Foreground

Once the background dries, begin drawing the fern plant. I've decided to go with the thinner leaves because I feel it looks more interesting. Since the fronds are so thin, draw them on the card with a green paint marker, rather than painting them.

Step 4: Add the Finishing Touches

Since this card is already detailed due to the fern's leaves, I keep this step minimal. Add a light pink circle to the bottom of the card to visually anchor the fern. Then add a few yellow dots to the center of the fern with a paint marker, and finish off the card with stars in the sky.

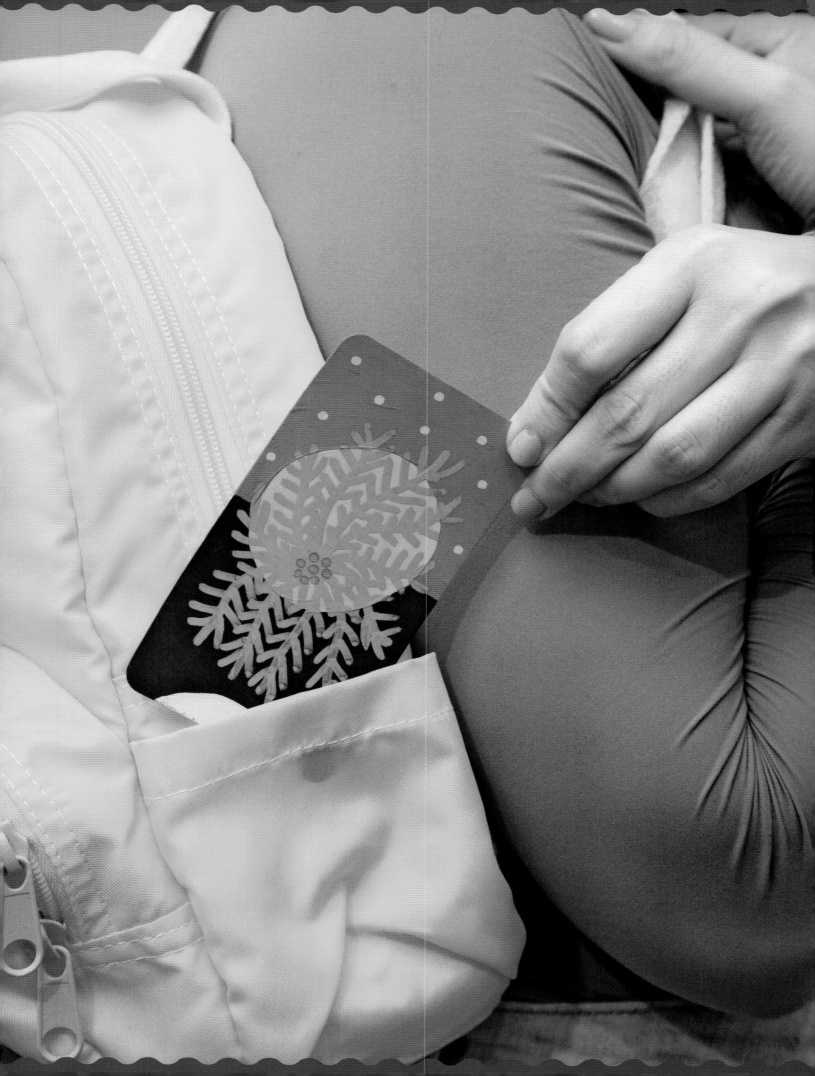

THE LOVERS

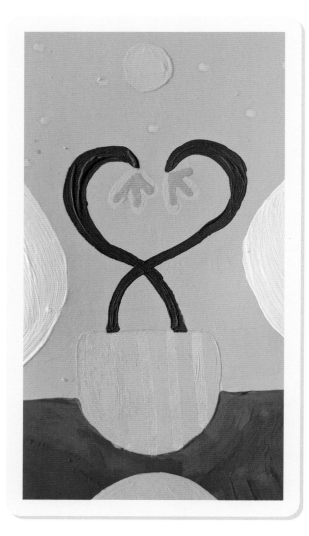

The Lovers card is part of the Major Arcana. It's a card about romance, relationships, and harmony. Seeing this card in a reading is always exciting for me—that's why I chose it as a lesson for this book!

COLOR SCHEME

Step 1: Sketch & Prep

Since this is our fourth card together, you know by now that it's time to sketch! Sketching is always optional, but I like to do it because it grounds my ideas and allows me to explore freely.

The Lovers card is about harmony, relationships, shared values, and joy. I immediately think of two plants together as a couple in the same planter. Since this is a Major Arcana card and not one of the Minor Arcana suit cards, you can choose any plant you want!

Play with a warm color palette. Purple conveys romance to me, so I've started with that and added complementary yellow. It's always a safe strategy to add a color's complement if you aren't sure what color to choose.

Go ahead and tape off your card's back, if you are doing that, and adhere your card to a piece of scratch paper for painting.

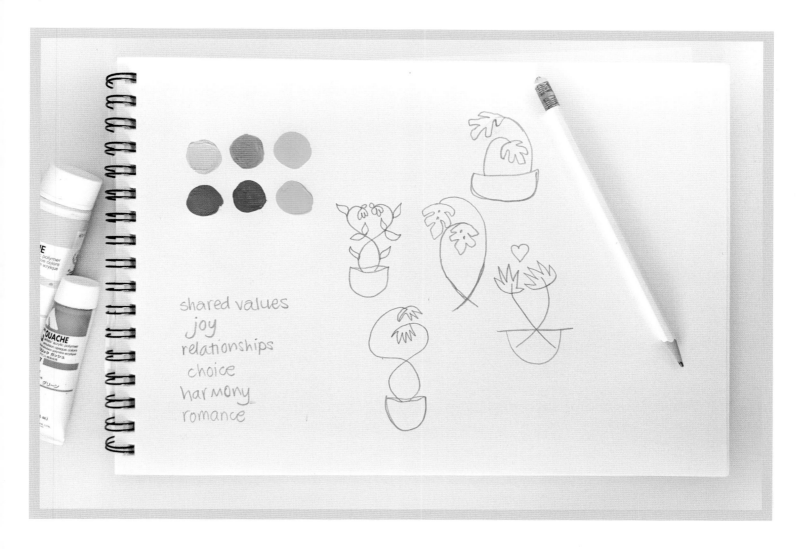

Step 2: Paint the Background

You may want to do something different with this background. Paint the yellow planter first, and add purple and lilac around it. This ensures that the yellow will still show up against the dark-colored background. Add two coats of gouache and set the card in front of a fan to dry.

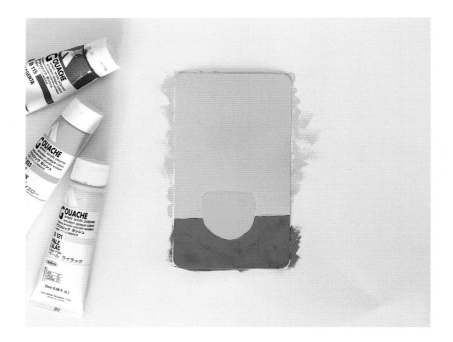

Step 3: Paint the Foreground

For the foreground, convey partnership by painting intertwining stems. Paint the stems first so you know how much room you have for the flower bud. Keep the buds simple if you don't have much room for detail. Next, add two white washes of color on the sides for visual interest. Lastly, add a sun at the top and a pink semicircle at the bottom to anchor the card. Once this dries, you can move on to the final step: details!

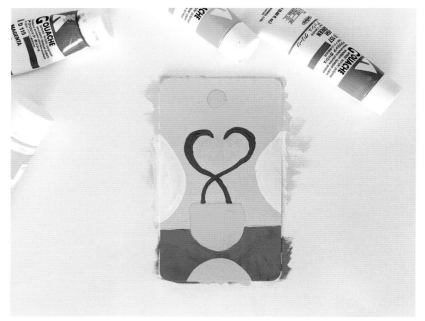

Step 4: Add the Finishing Touches

Details time! Not too much is needed to avoid taking away from the card's focus—the intertwined plant stems. Just use a cream-colored paint marker to add some simple stripes to the planter. *Voilà!*

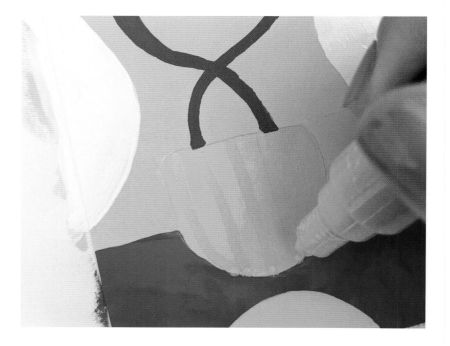

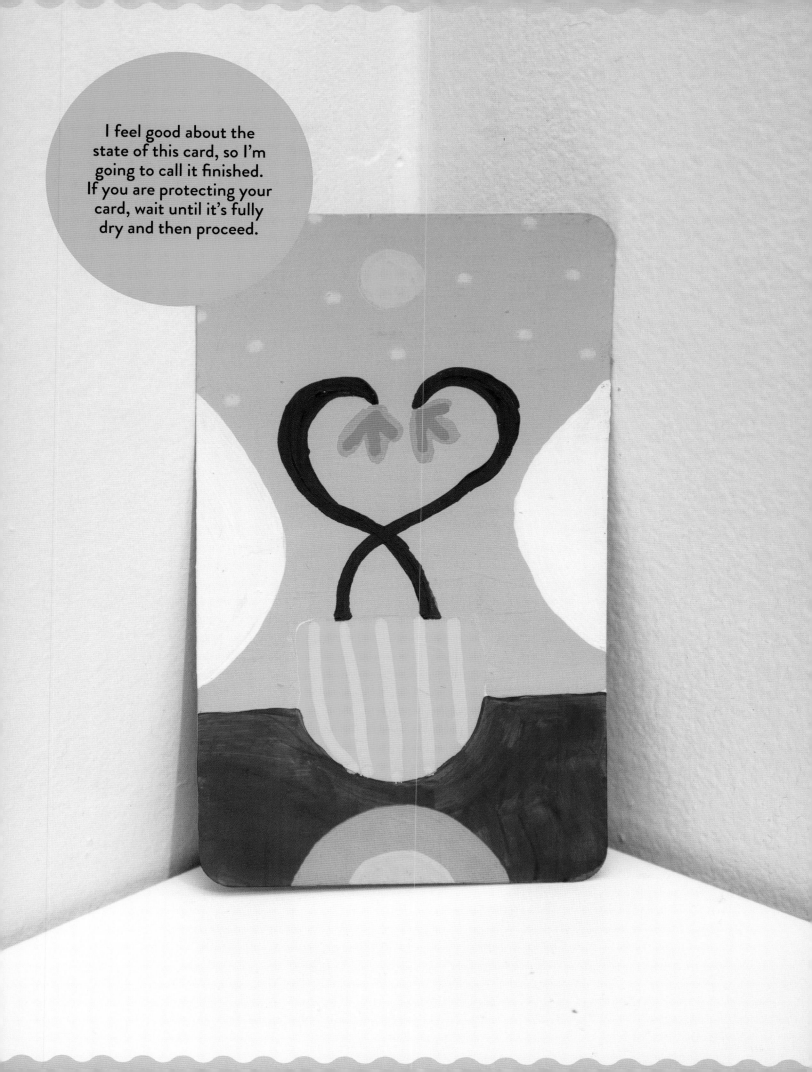

THE STAR

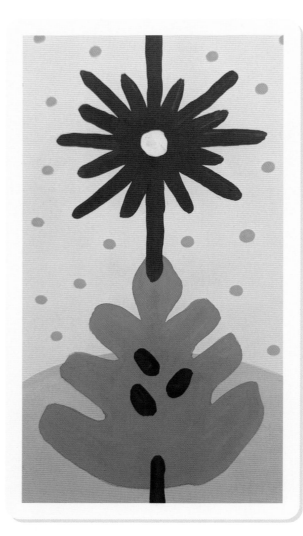

The Star is part of the Major Arcana. It's a card of serenity that asks you to find the peace within yourself, even just for a moment.

COLOR SCHEME

Step 1: Sketch & Prep

I don't have an immediate image for this card, so I've sketched cool plants that would look nice with a large star. I draw a banana leaf and a monstera, and after considering them both, I feel the softer edges of the monstera leaf will complement the sharper edges of the star. For the color palette, I've chosen calming ultramarine blue paired with muted pinks and rich greens.

This card's composition is tricky because there are two dominant elements: a star and a monstera. Placing them on opposite ends of the card gives balance, as you'll see in the following steps.

Go ahead and tape off your card's back (if you are doing that) and adhere your card to a piece of scratch paper for painting.

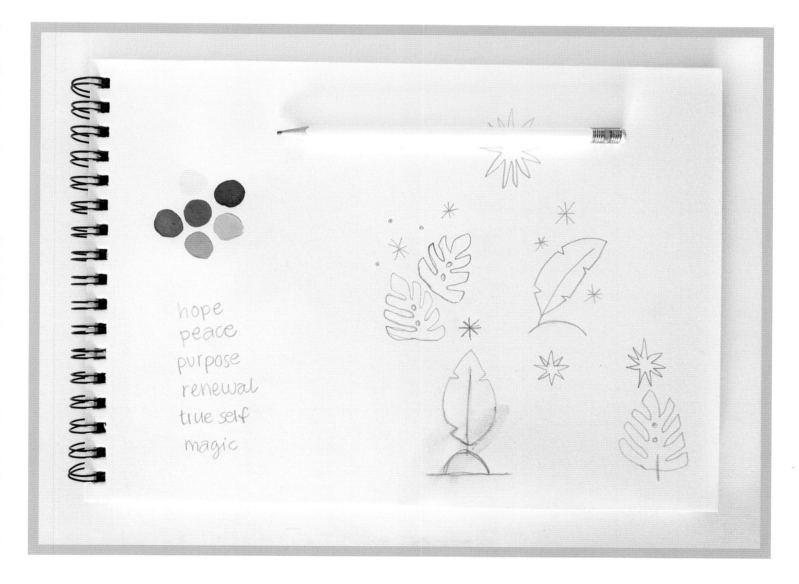

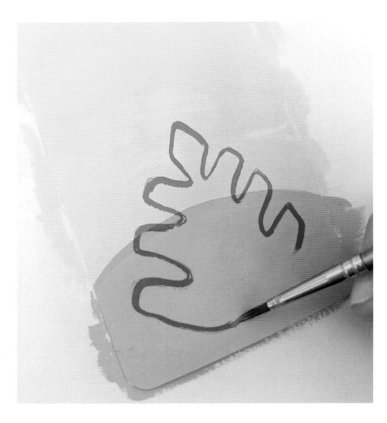

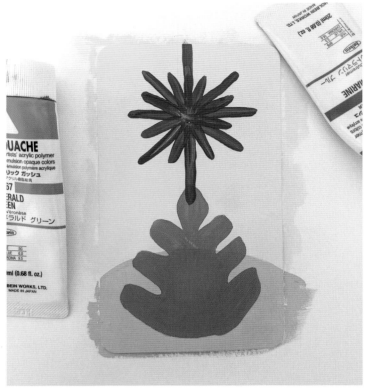

Step 2: Paint the Background

Start by adding pale pink gouache to the upper two-thirds of the card and use a light magenta gouache for the bottom third. Apply a second coat for each and let it dry completely before moving on to the foreground imagery.

Step 3: Paint the Foreground

Begin the foreground with the monstera. The star is slightly more important for this card, so you can keep the monstera small and on the bottom half of the card. I've used an emerald-green gouache for the leaf.

Step 4: Add the Finishing Touches

Details are important on this one. First, add dark spots to the monstera leaf using peacock-blue gouache. Use this same color to add a stem to the leaf, making it extend off the page to complement the star.

Next, use a turquoise paint marker to add stars to the sky. I thought I'd be done at this point, but something still felt like it was missing. I've gone rogue and added a cream-yellow circle to the center of the star. This makes the star look more radiant. I know yellow wasn't on my planned color palette, but it's OK to deviate from the plan if your intuition tells you to! Feel free to do the same with your own cards.

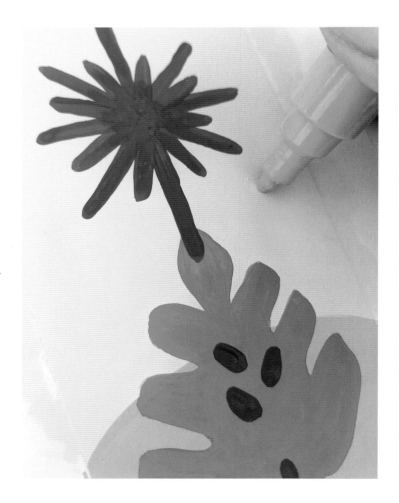

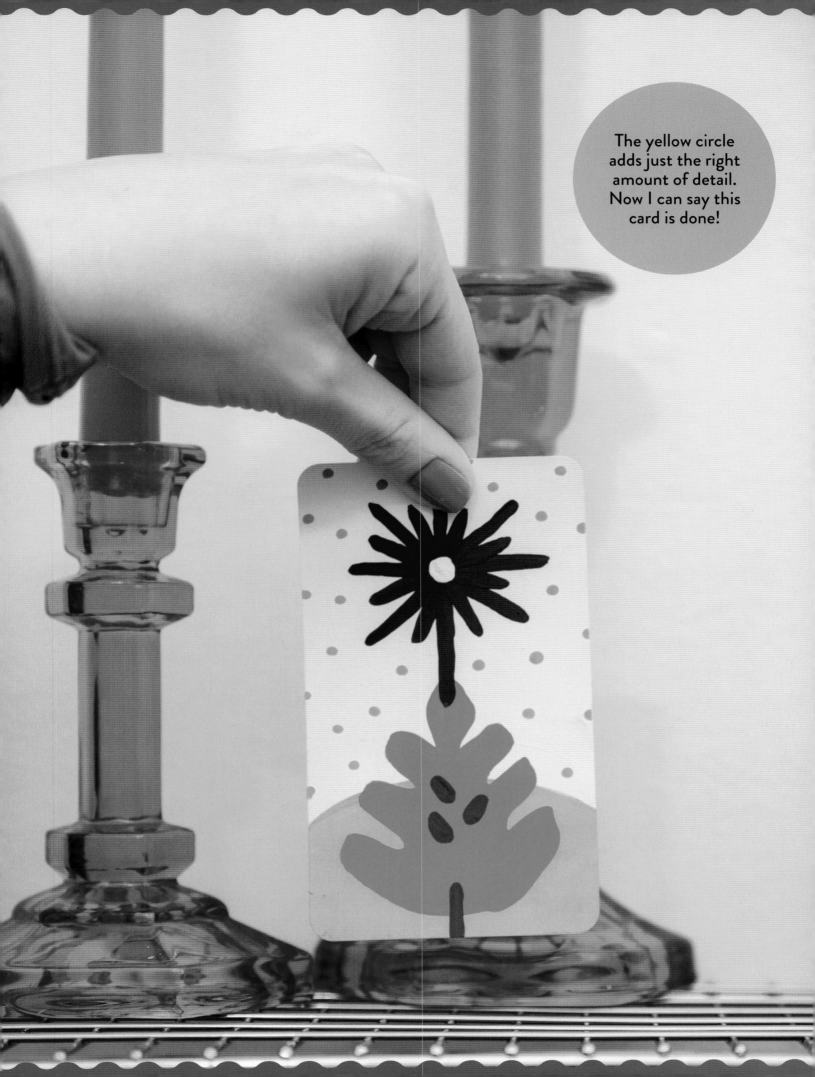

The yellow circle adds just the right amount of detail. Now I can say this card is done!

THE TOWER

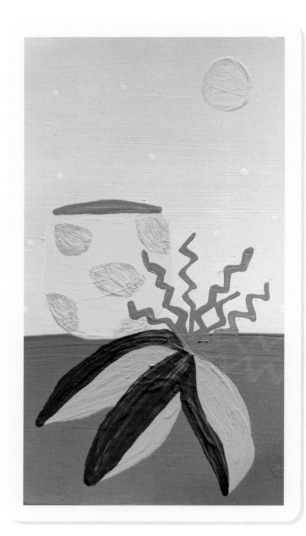

The Tower card is part of the Major Arcana and it can be a bit unsettling when it turns up. A visually violent card that depicts destruction and chaos, it usually signifies the end of something or a massive transformation.

· THE TOWER ·
COLOR SCHEME

Step 1: Sketch & Prep

The Tower card is about upheaval and chaos. Things are going wrong in life, maybe because they weren't done correctly from the start or because change is needed. Rebirth can be a result. Since the meaning of the card is negative with a positive twist,

I decide to use chaotic imagery with a brighter color palette. I've sketched a few ideas with uprooted or upside-down plants. For the color palette, I've started with yellow hues and added in shades of blue and green.

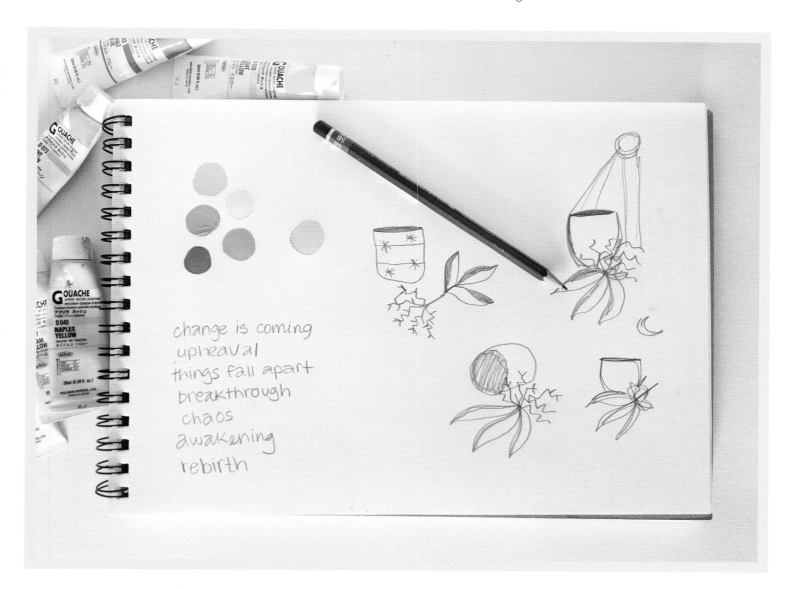

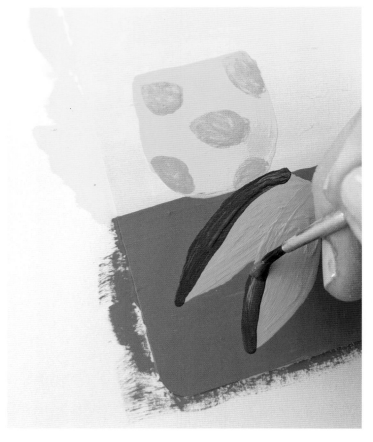

Step 2: Paint the Background

Start by painting the top half of the card a light yellow and adding a royal blue to the bottom half. You may need to do several coats, especially if the yellow comes out a little thin.

Step 3: Paint the Foreground

Add a deeper yellow flower pot in an upright position toward the left of the card. Make sure to save room for the uprooted plant! Next, paint leaves on the ground using mint green.

Then add some detail to the leaves with a darker green gouache, as well as monochromatic polka dots to the pot using an ash-yellow shade.

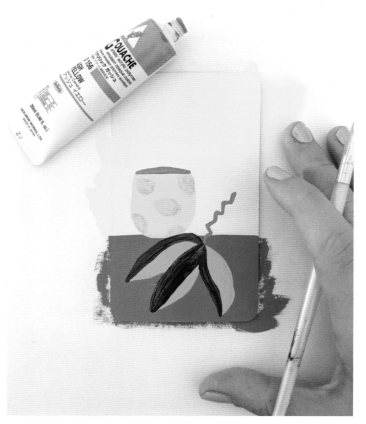

Step 4: Add the Finishing Touches

I've decided to paint (rather than draw) the roots of the plant. Use ash-yellow gouache and a thin brush to paint roots sticking up into the air. Then add dots to the sky using a white paint marker.

To make the composition feel more balanced, add a yellow sun in the upper-right corner.

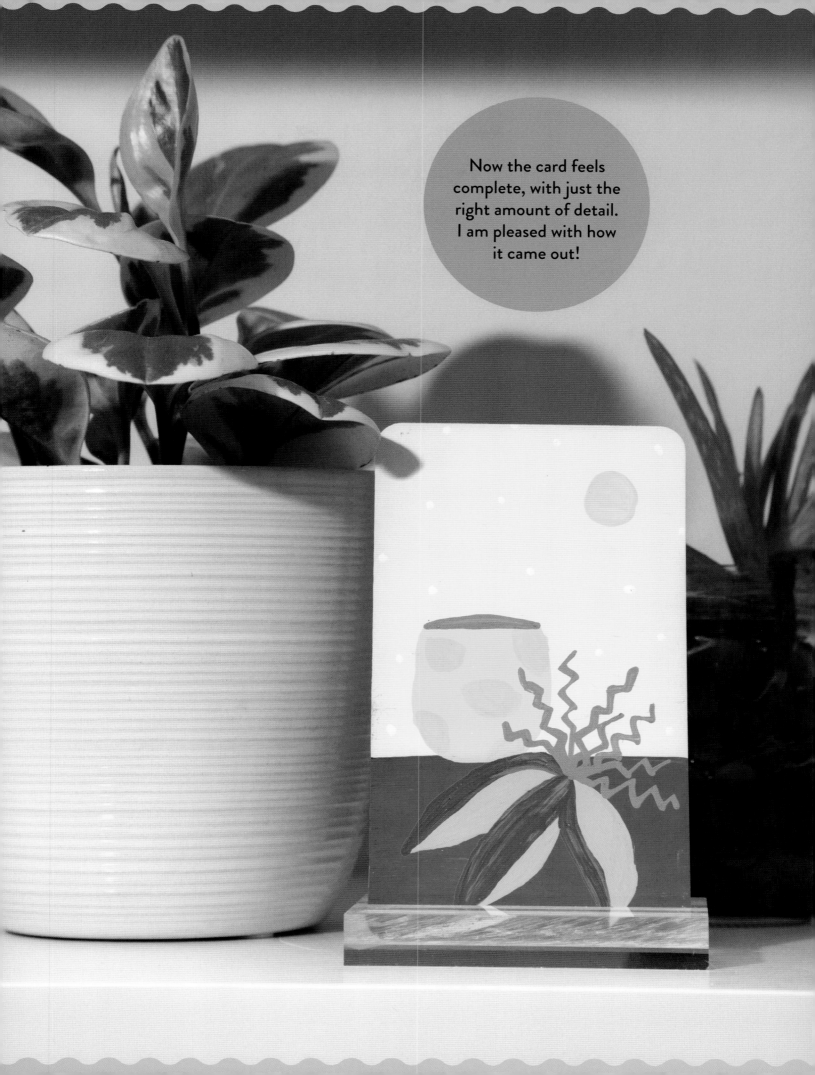

Now the card feels complete, with just the right amount of detail. I am pleased with how it came out!

WHEEL OF FORTUNE

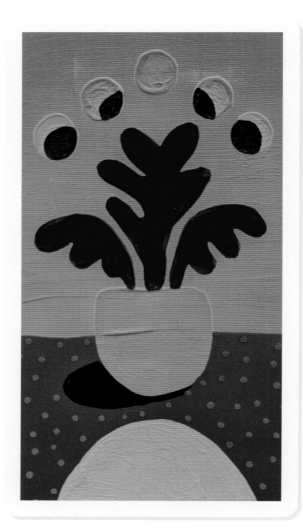

Meet the Wheel of Fortune, a card about the universe. If you love control, you may have to step back and let things unfold as they ultimately will. This is the energy and spirit of the Wheel of Fortune. It's a wheel that's always turning, and when you're in its path, it's best to surrender and let life happen.

· WHEEL OF FORTUNE ·
COLOR SCHEME

Step 1: Sketch & Prep

To me, the Wheel of Fortune feels like the most mystical card in the entire deck. I want to use unexpected yet alluring colors and have settled on a bright coral with purple accents. I also want the imagery to convey an air of mystique, so I sketch out a fern plant with funky leaves reminiscent of a staghorn fern.

I choose this plant because the leaves stand out and are very funky-looking. Above the fern, I decide to add the phases of the moon, indicating cycles and the ever-rotating Wheel of Fortune.

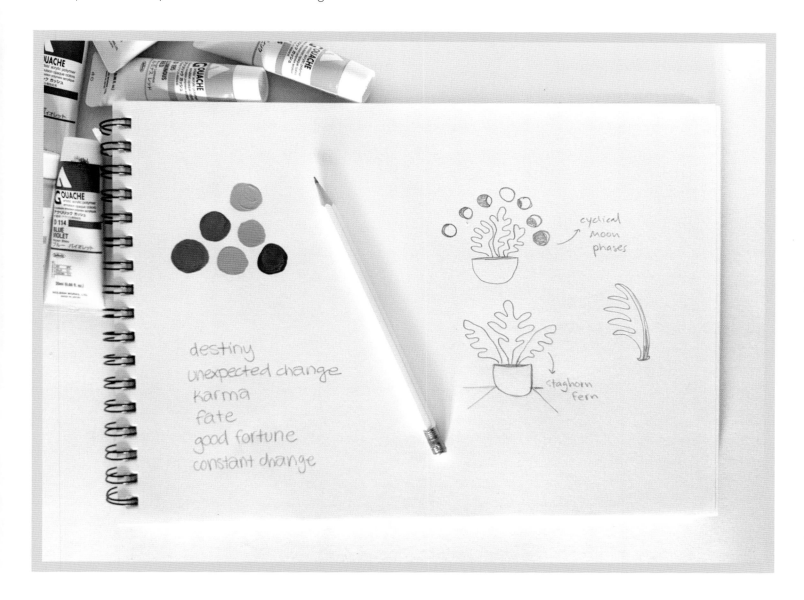

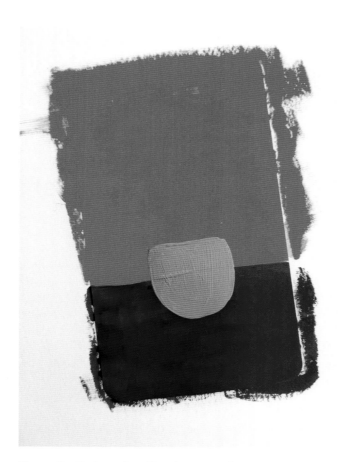

Step 2: Paint the Background

I want coral to be the dominant color, so I've used it for the top two-thirds of the card. For the bottom third, use a deep purple and paint a light magenta plant pot over both colors once they have dried.

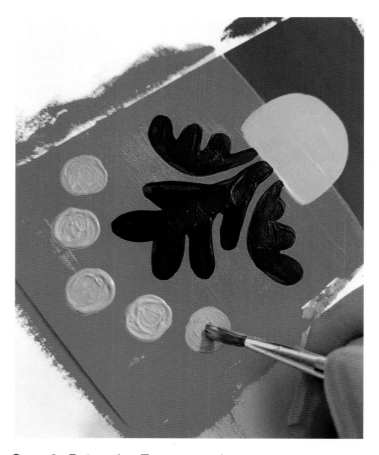

Step 3: Paint the Foreground

Once the background is dry, use a thin brush to draw the outline of the fern plant. You can use a blue-purple shade of gouache for this. Then select a lilac color and use it to paint the phases of the moon above the fern plant.

Step 4: Add the Finishing Touches

Once the foreground is dry, add a shadow to the plant using a black paint marker. Sometimes little things like shadows add the perfect amount of interest to a card—especially this one, since I'm going for a mystical vibe. Paint a lilac arch on the bottom of the card to anchor the composition. Next, to liven up the large wash of deep purple, use a slightly lighter purple marker to add dots. The final (and most nerve-wracking) step is to use the same black marker to draw in the phases of the moon.

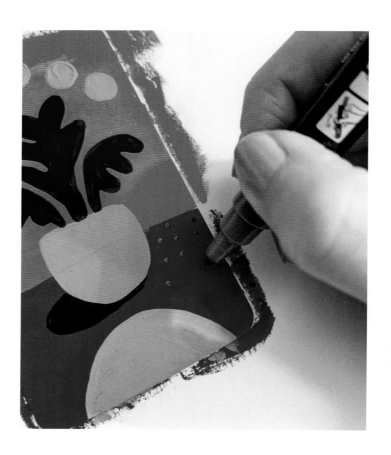

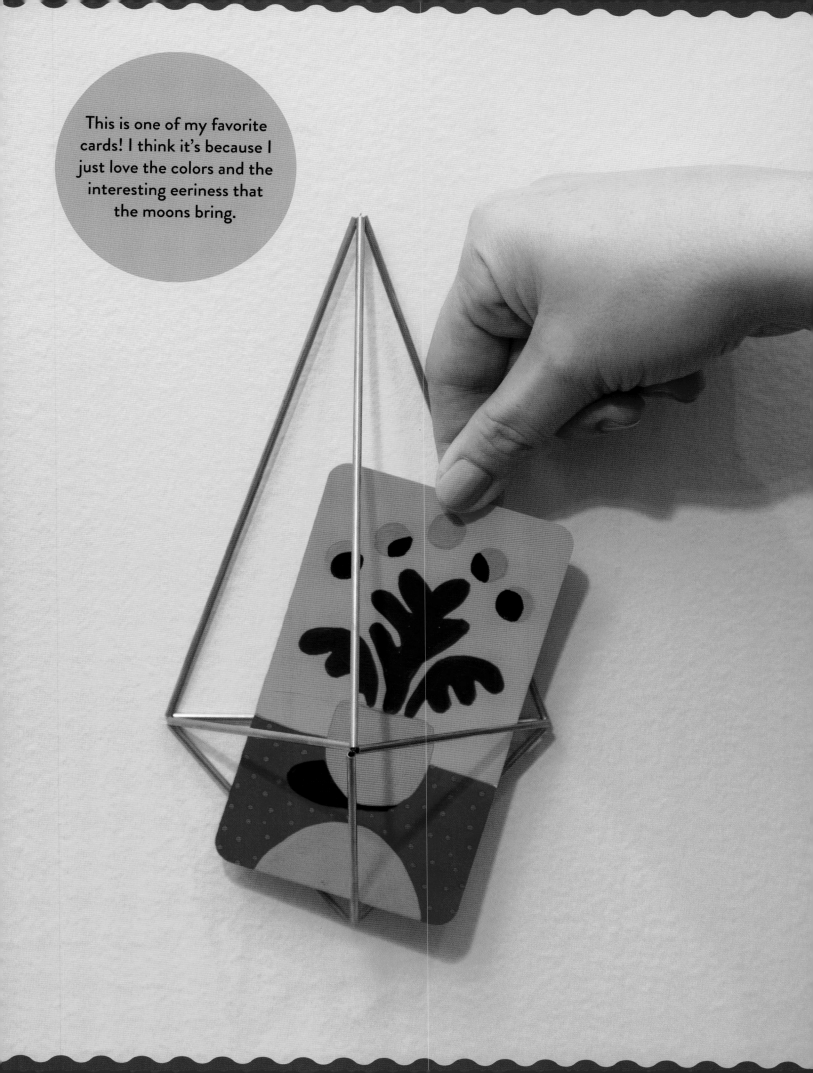

This is one of my favorite cards! I think it's because I just love the colors and the interesting eeriness that the moons bring.

THE HANGED MAN

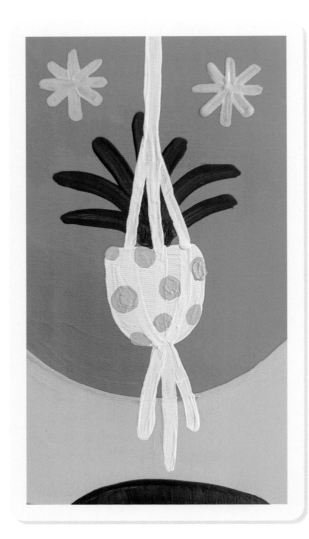

Meet The Hanged Man, a card of stillness and surrender.
It suggests that you roll with the punches of life.
Sometimes it's best to be still and gain a new perspective,
rather than charging ahead with your plans. Good things
can come if you stop, sit, and wait.

COLOR SCHEME

Step 1: Sketch & Prep

Since The Hanged Man is all about hanging out and waiting, pausing, and reflecting, I know I have to paint a hanging plant for this card. I've sketched possible ideas and worked on a color palette. The darker greens suggest prior stability in one's life. Then use pink to shake things up and symbolize the new perspectives that this card can sometimes bring. Lastly, doing a plant in a macrame hanger feels just right! It's simple, yet visually interesting.

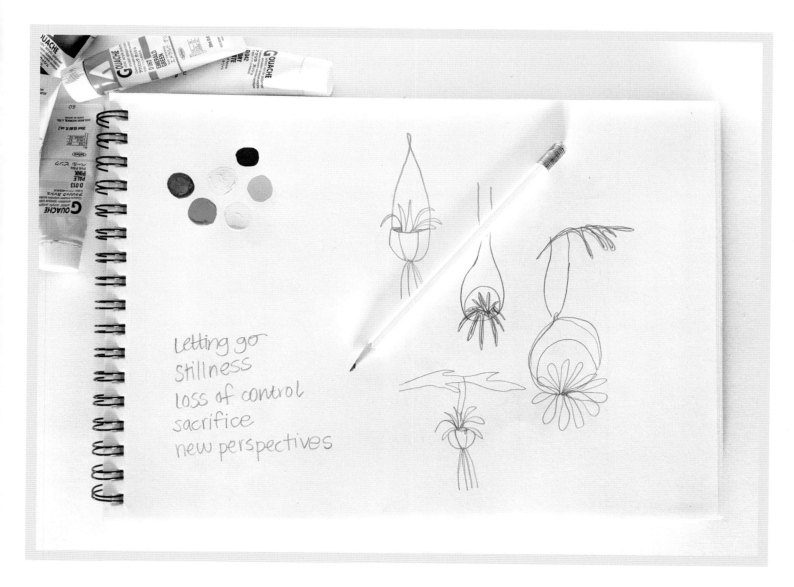

Letting go
Stillness
loss of control
sacrifice
new perspectives

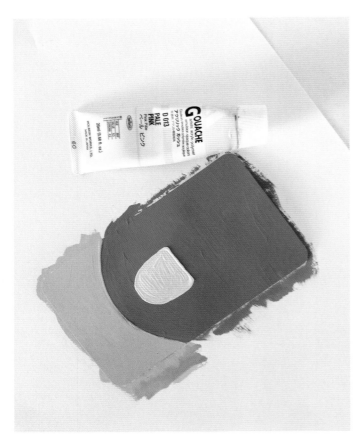

Step 2: Paint the Background

Start by painting the bottom third of the card pink, and then add a deep emerald to the empty two-thirds. Then rotate the card and add a baby pink plant pot.

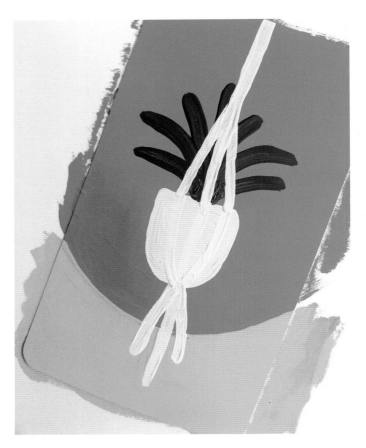

Step 3: Paint the Foreground

Next, use a dark green to paint a teeny snake plant. Use ivory for the macrame hanger and a thin brush to paint the line work. Add tassels to the bottom of the hanger, and make it extend all the way past the top barrier of the card.

Step 4: Add the Finishing Touches

Time for details, my favorite part! Use a mid-toned pink to add polka dots to the plant pot and stars to the open green space at the top of the card. Then use the same deep green from the plant leaves to add a tiny arch anchor to the bottom of the card.

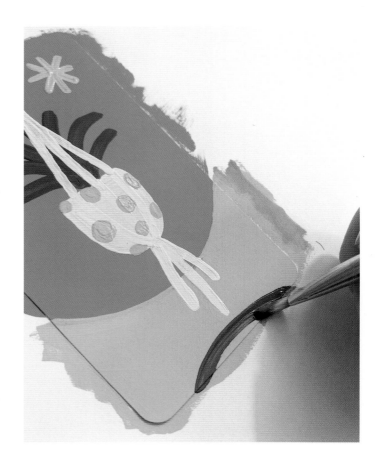

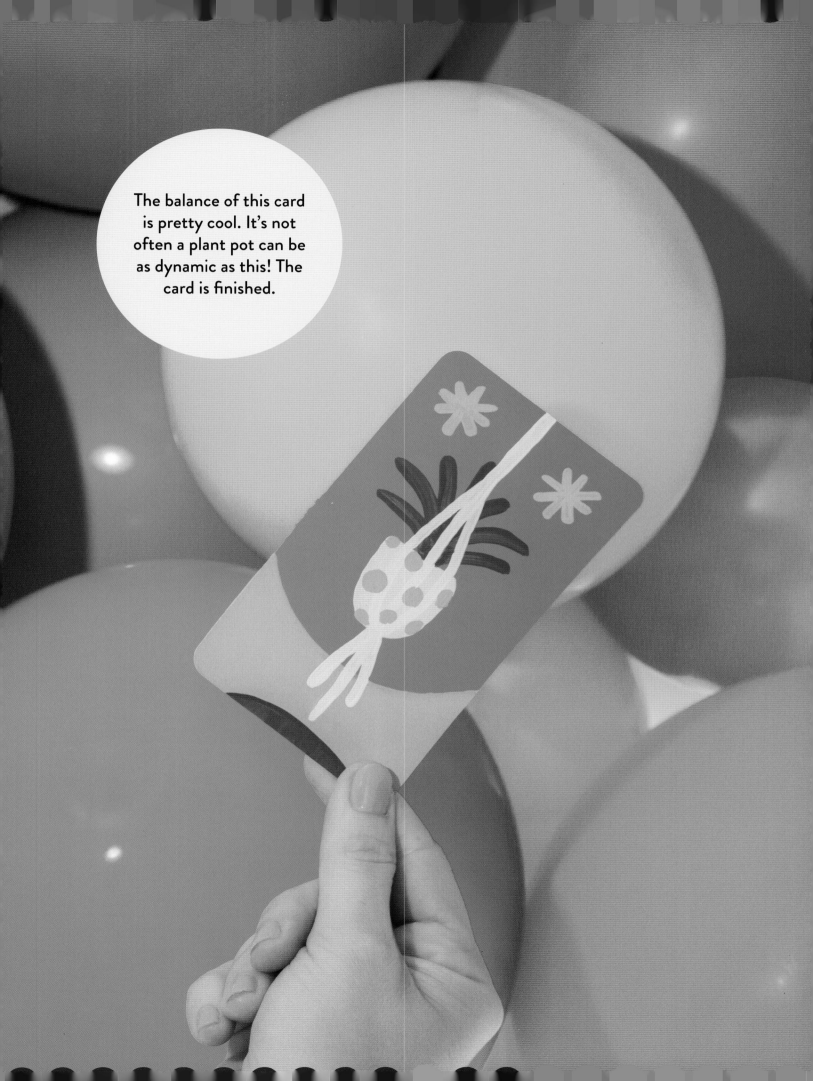

JUDGMENT

The Judgment card is one of my favorites. It's about freeing yourself, and in some cases, about letting go and forgiving. If this card appears in a reading, think about what you're holding on to and reflect on whether you'd be better off letting it go.

· JUDGMENT ·
COLOR SCHEME

Step 1: Sketch & Prep

I want to depict the idea of personal freedom, so I've sketched out a few plants with suns or radiating beams of light behind them. I want this card to feel light and bright. This is an alternate take on the Judgment card, which sometimes dredges up bad people, feelings, and negativity, but I've chosen to focus on the positive part—ultimate forgiveness and letting go. The colors are bright and reflect this optimism.

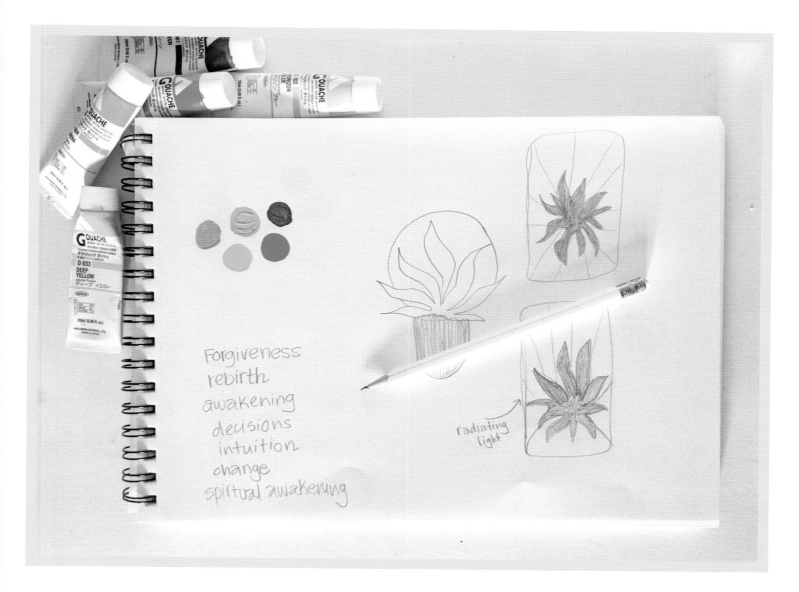

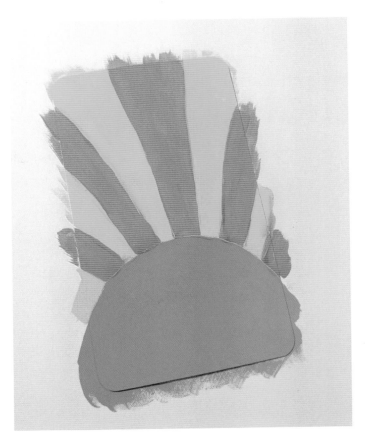

Step 2: Paint the Background

I want the plant to sit on a half-circle, so I paint that first using a sky-blue gouache. Next, add radiating beams of light with neon pink and golden-yellow gouache.

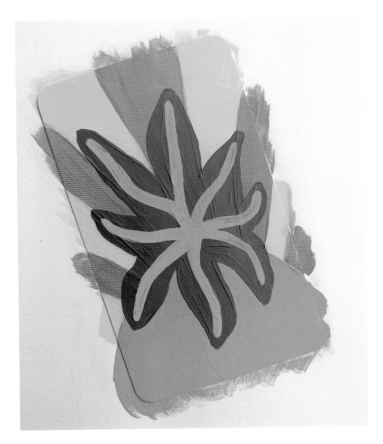

Step 3: Paint the Foreground

Once the background is fully dry, add an emerald-green plant in the center. I'm not really sure what type of plant this is; perhaps I've invented it! I want something large with fun leaves that will fill the space. Use a thin brush and lime gouache to add some linework once it's dry.

Step 4: Add the Finishing Touches

The colors are pretty intense on this one, so keep the composition minimal, including the details. Use a bright pink paint marker to add lines radiating out of the bottom of the plant and a white marker to add dots to the sky.

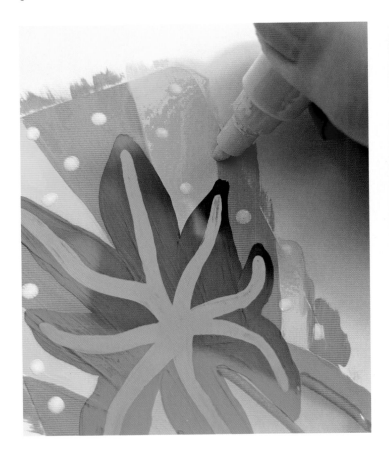

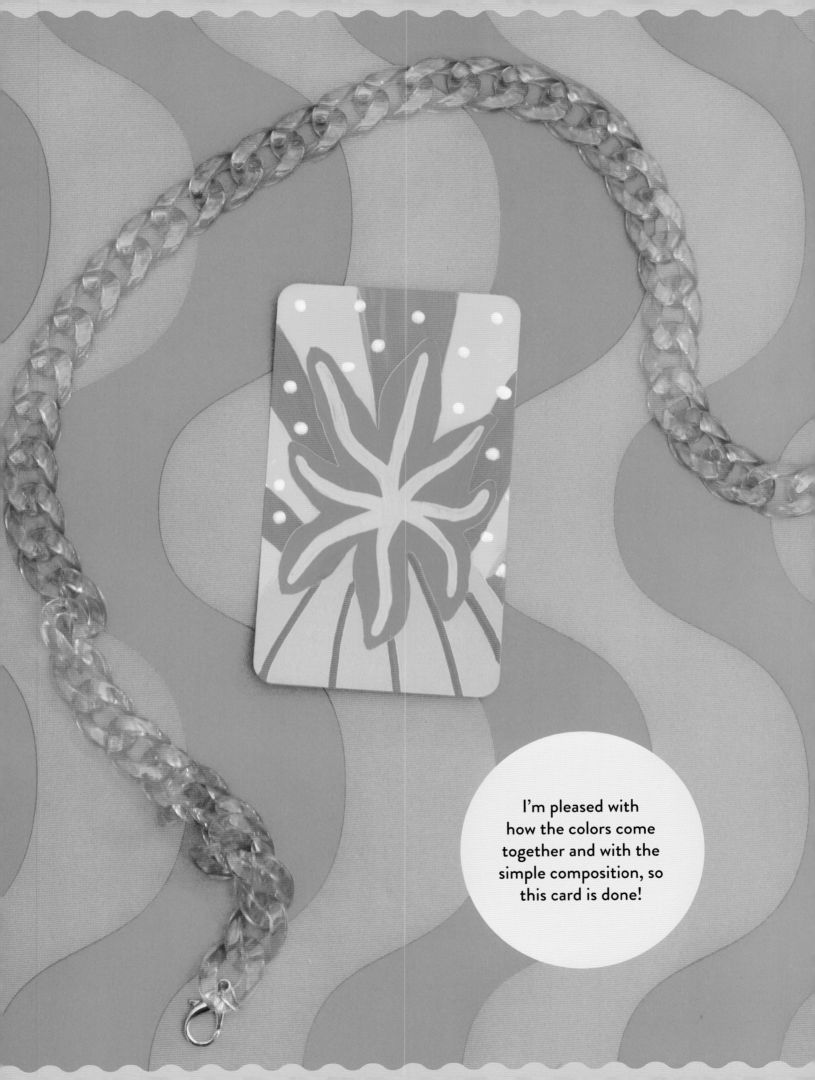

I'm pleased with how the colors come together and with the simple composition, so this card is done!

STRENGTH

The Strength card is about harnessing your inner focus. It means being strong—but not necessarily physically strong. It's more about being calm and in control of your emotions. When this card shows in a reading, it's asking you to dig deep and master your emotions the best way that you can.

COLOR SCHEME

Step 1: Sketch & Prep

The color blue keeps speaking to me for this one, likely because it's known to evoke feelings of calm. I've based my color palette off several shades of blue and added a few greens and pinks in for good measure. I decide to draw a banana leaf plant. These towering plants symbolize strength for me and are the perfect visual element for this card.

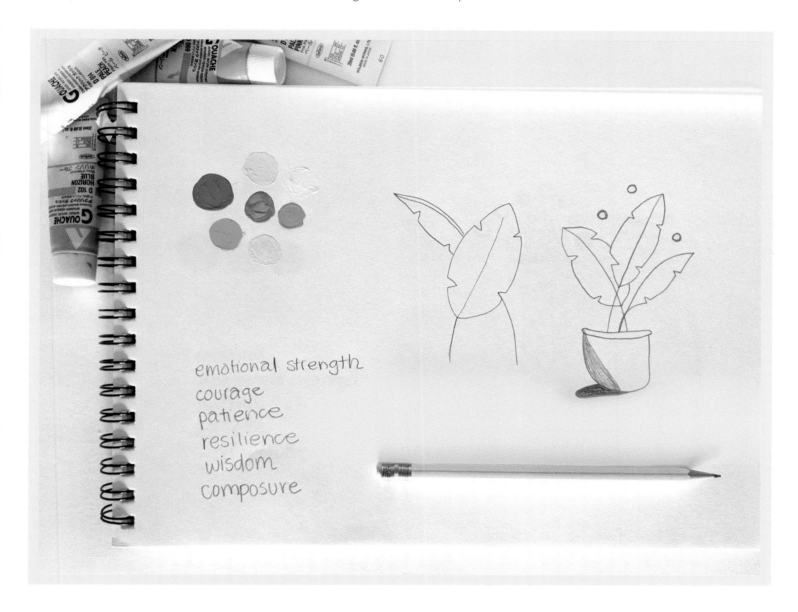

emotional strength
courage
patience
resilience
wisdom
composure

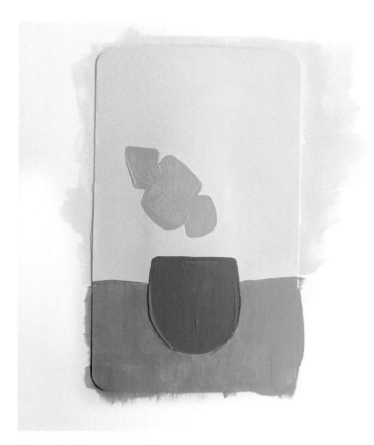

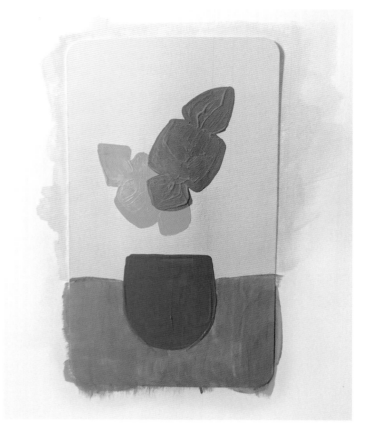

Step 2: Paint the Background

I don't want the card to appear too dark, so I use a baby pink for the top two-thirds. Add a bright blue plant pot and paint the bottom third around it using turquoise green. Once the pink is dry, add one banana leaf in greenish-blue—getting started on the foreground a bit early!

Step 3: Paint the Foreground

Once that leaf has dried, use a true green gouache to paint another leaf over the top.

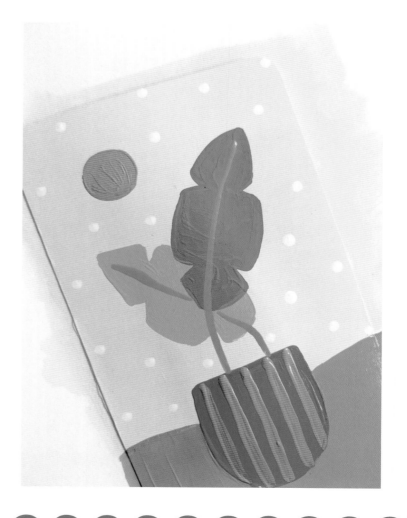

Step 4: Add the Finishing Touches

For finishing touches, use a thin brush to add pink stripes to the pot, and add a magenta sun to the upper-left corner to help balance the composition. Finally, use a lime-green paint marker to add stems to the leaves and a white marker to add stars to the sky.

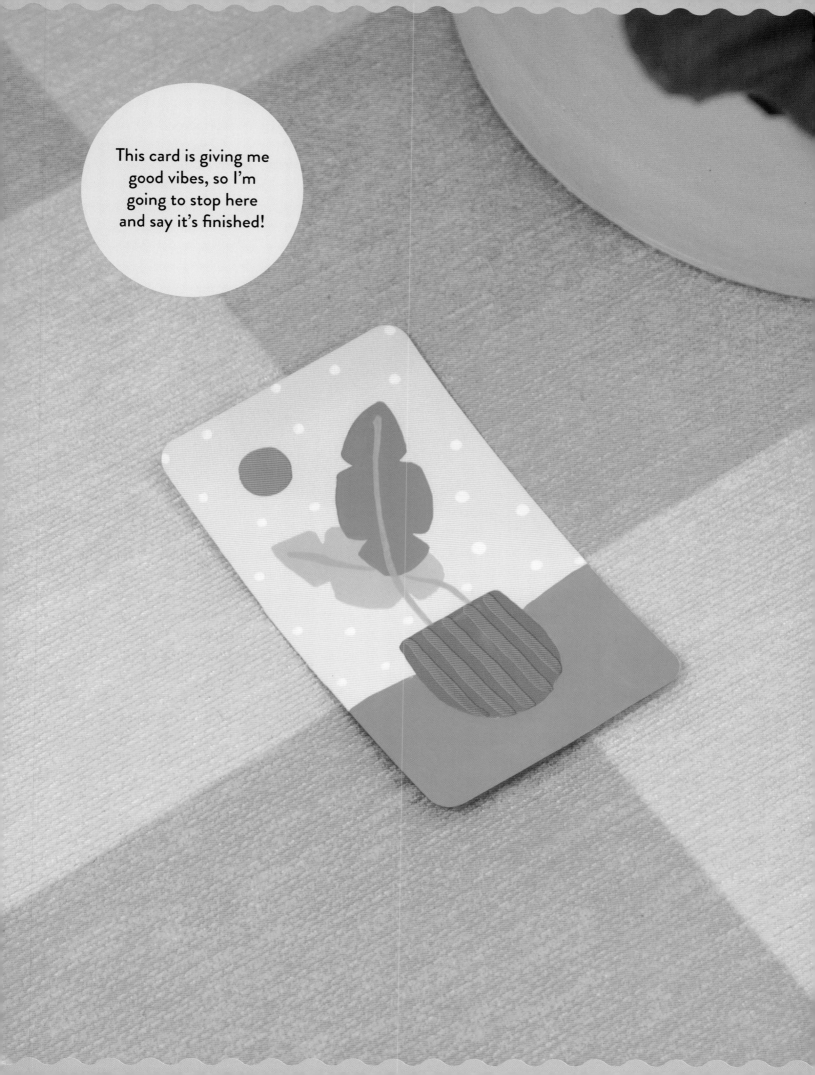

FOUR OF CUPS

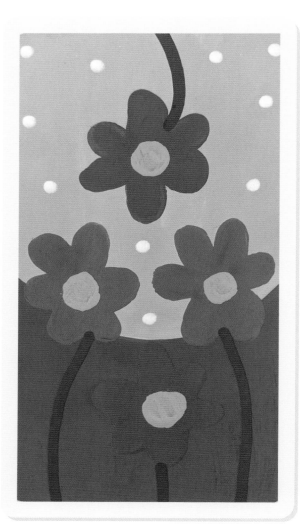

The Four of Cups can be interpreted several ways. One way is about apathy, dullness, and disinterest. Maybe you aren't excited about things in your life anymore, or maybe you aren't seeing opportunities to change a situation because you are so wrapped up in your own internal thinking. This card has a less positive meaning than some of the others we've painted, and you'll see that in the visual choices we make in the next steps.

COLOR SCHEME

Step 1: Sketch & Prep

Since this card represents apathy, a muted color palette works well. Earlier in the book, I've discussed choosing daisies to represent the Cups suit. Daisies are typically associated with cheerful imagery, so to convey a message of dullness and disinterest, use dull, less saturated colors.

Sketch a few layouts for the four daisies. Sketching helps you plan placement when there are a lot of elements to put on a card.

Then you might choose to tape off the back of your card and adhere it to a piece of scratch paper for painting.

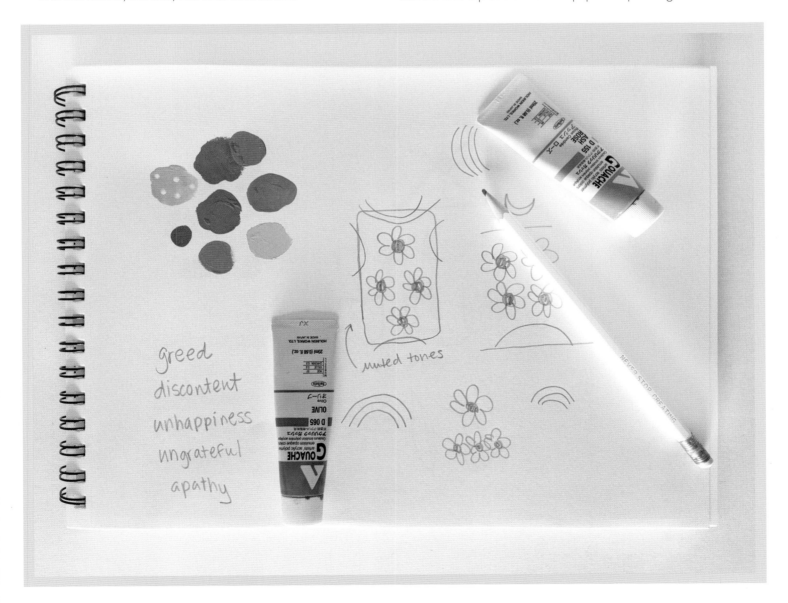

Step 2: Paint the Background

For the background, I've decided to go with a dip downward, since it feels more negative than a dip upward or a flat surface. Apply two coats of two shades of green gouache.

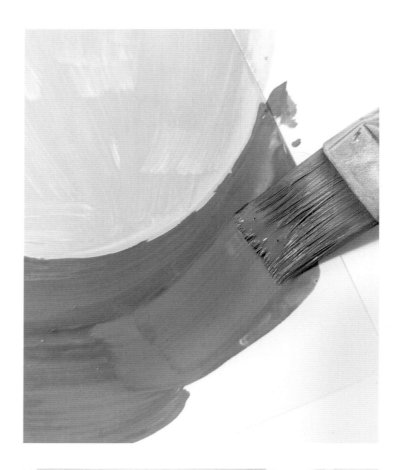

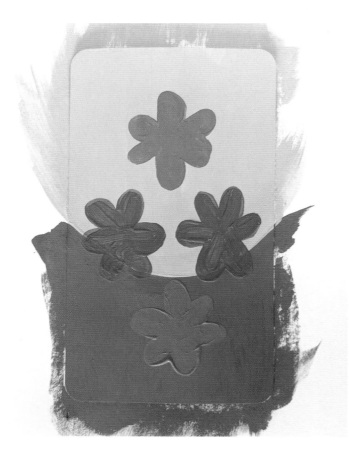

Step 3: Paint the Foreground

Next, paint four daisies in a diamond formation. Try to keep the side daisies equidistant from the left and right edges.

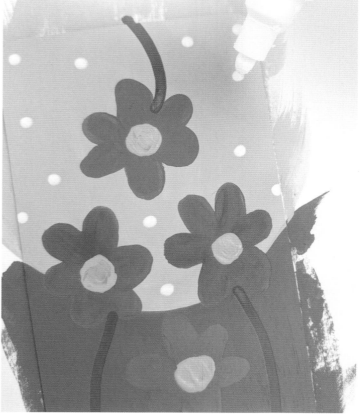

Step 4: Add the Finishing Touches

For finishing touches, use a wine-colored paint marker to add stems to the daisies. Then apply a light orange gouache to add circles to the centers of each daisy. Finally, finish the card with some white dots on the upper half of the card.

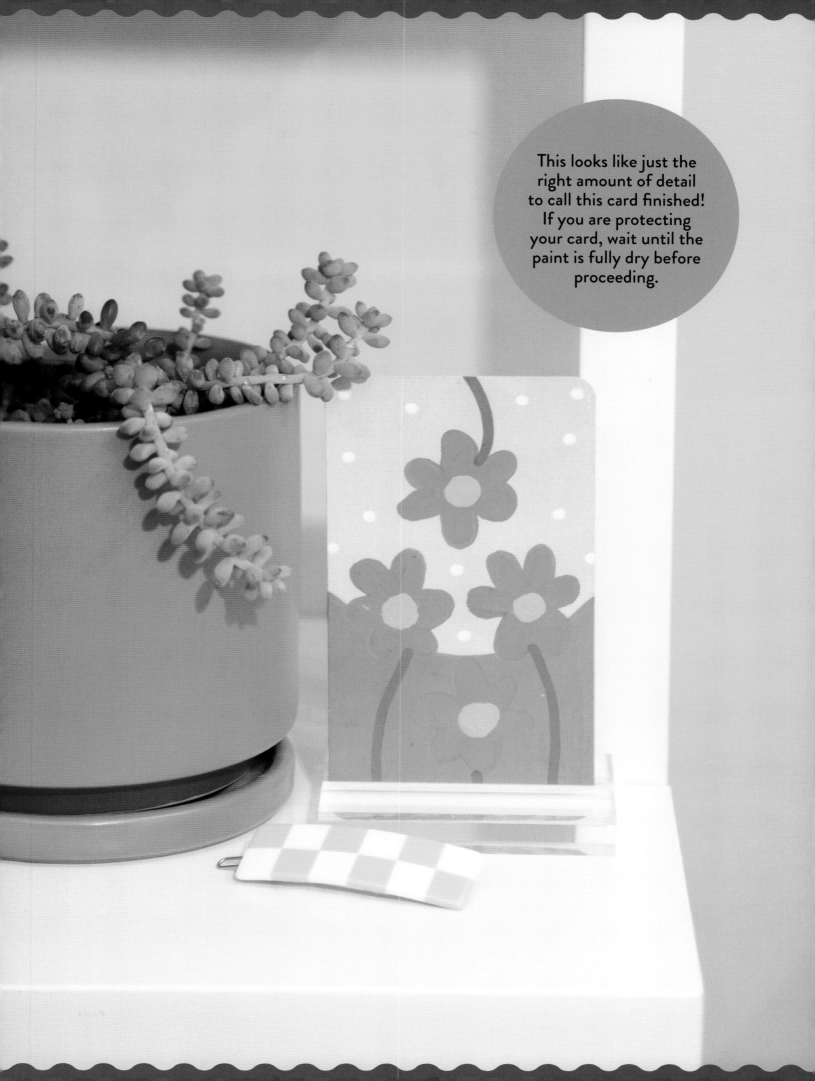

This looks like just the right amount of detail to call this card finished! If you are protecting your card, wait until the paint is fully dry before proceeding.

TEN OF SWORDS

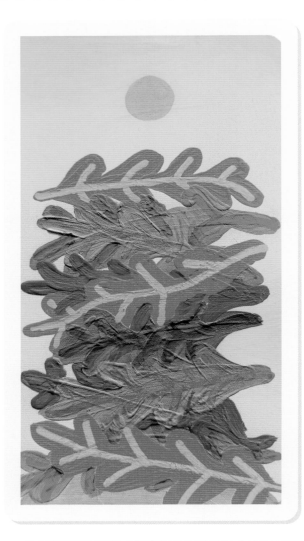

The Ten of Swords card is part of the Minor Arcana and it is a very dark card. It usually signifies an abrupt or unexpected ending—whether it's a relationship with someone, a job loss, or a betrayal of your trust. This card is the end of the line and feels like rock bottom.

COLOR SCHEME

Step 1: Sketch & Prep

This is a tough card to paint. I have to somehow fit 10 swords into a tiny space, so sketching is a super-important step for cards like these. It's good to form a plan in advance so you don't have to start over or paint over your progress.

For this card, I've decided to lay the sword plants on top of one another. I need a composition that feels like utter defeat, and visually, this seems to accomplish that goal. In my sketch, I've made sure to count all 10 of the swords, to double-check that I got them all!

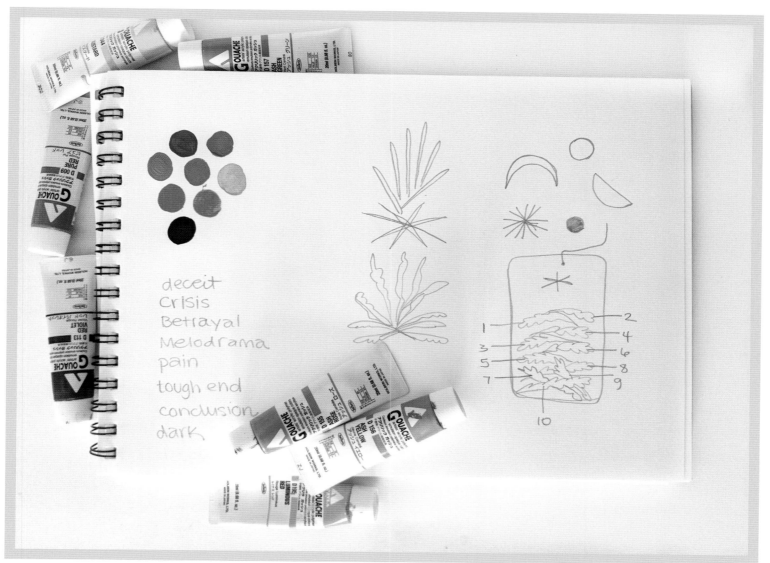

Step 2: Paint the Background

I'm using jewel tones for this card, with a focus on red. Red is about power, and since this card is about defeat, it offers an interesting juxtaposition of concepts. Power versus defeat. Begin by painting the background a mustard yellow and adding an ash-yellow anchor to the bottom.

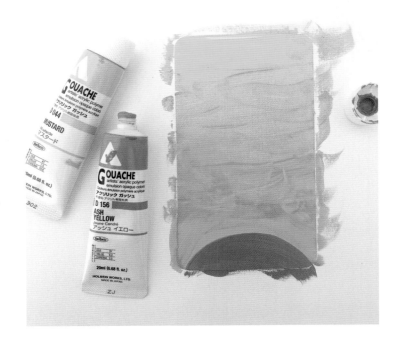

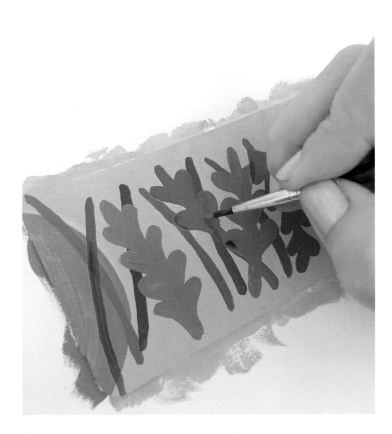

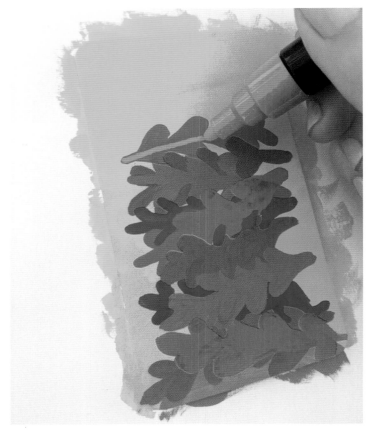

Step 3: Paint the Foreground

Get ready—this foreground is going to be tough. Since the sword plants have several leaves per stem, you can get the layout right by painting the stems first. Once you feel good about the stacked stems, add leaves to them. This is pretty time-consuming and may not look perfect, but the meaning comes across (which is the most important)!

Step 4: Add the Finishing Touches

Since this card is so visually complex, you can use a paint marker to add detail to each stem. I've chosen a fluorescent-red marker for the red stems, a green one for the green stems, a lilac one for the purple stems, and a copper one for the brown stems. This really brings the card to life!

Once the stems are done, add a neon-red sun to the top of the card.

And we're finished!
Aren't you excited that you
made it through a card with
10 objects on it? They are
some of the most difficult to
paint, so congratulations!

ACE OF PENTACLES

~~~~~~~~~~~~~

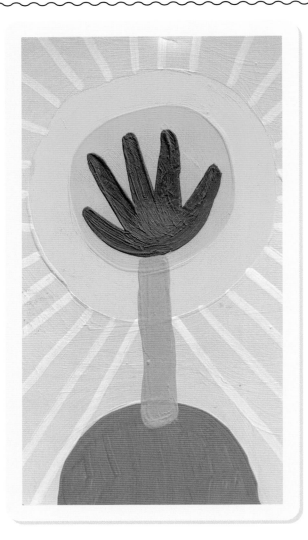

The Ace of Pentacles card is part of the Minor Arcana and a sign of new financial beginnings. A seed has been planted and you can bet it will bloom into something tangible—whether it's a financial endeavor, a new career path, or your first home. The Pentacles suit is about worldly possessions, and the Ace symbolizes an exciting new endeavor!

# COLOR SCHEME

## Step 1: Sketch & Prep

Earlier in the book, I decided to use these little handlike shapes for the Pentacles suit. Since this is the Ace card, you'll only need one of them. This card symbolizes prosperity, wealth, and new endeavors, so I think it would be nifty to put the hand shape in a yellow circle (a nod to a gold coin). It's subtle, but I think it works! I've decided to use the gold coin as inspiration for the color palette, and I've chosen varying shades of yellow with hints of orange, red, and even a pop of green.

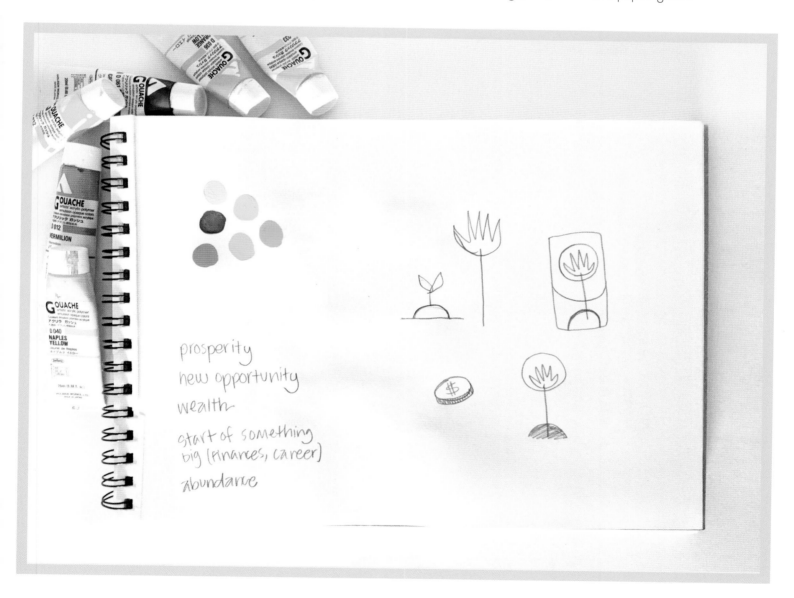

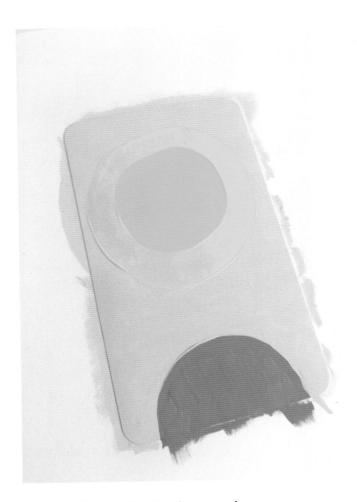

## Step 2: Paint the Background

I've done something unconventional for this card's background and started with the yellow circle—mostly because I want it to be pure yellow without risk of the background color showing through. From there, add a lighter yellow border to the circle, as well as a red anchor, and fill in the white space with Naples yellow gouache.

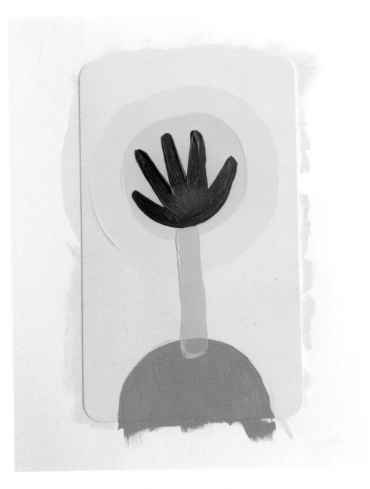

## Step 3: Paint the Foreground

Once the background is fully dry, add the hand shape to the circle using green gouache. Attach the shape to the red anchor by creating an orange stem with a thick brush.

## Step 4: Add the Finishing Touches

I want the card to radiate the magical feeling of ambition and success, so I've added lines using a white paint marker. The lines start from the lighter yellow circle and radiate off the card.

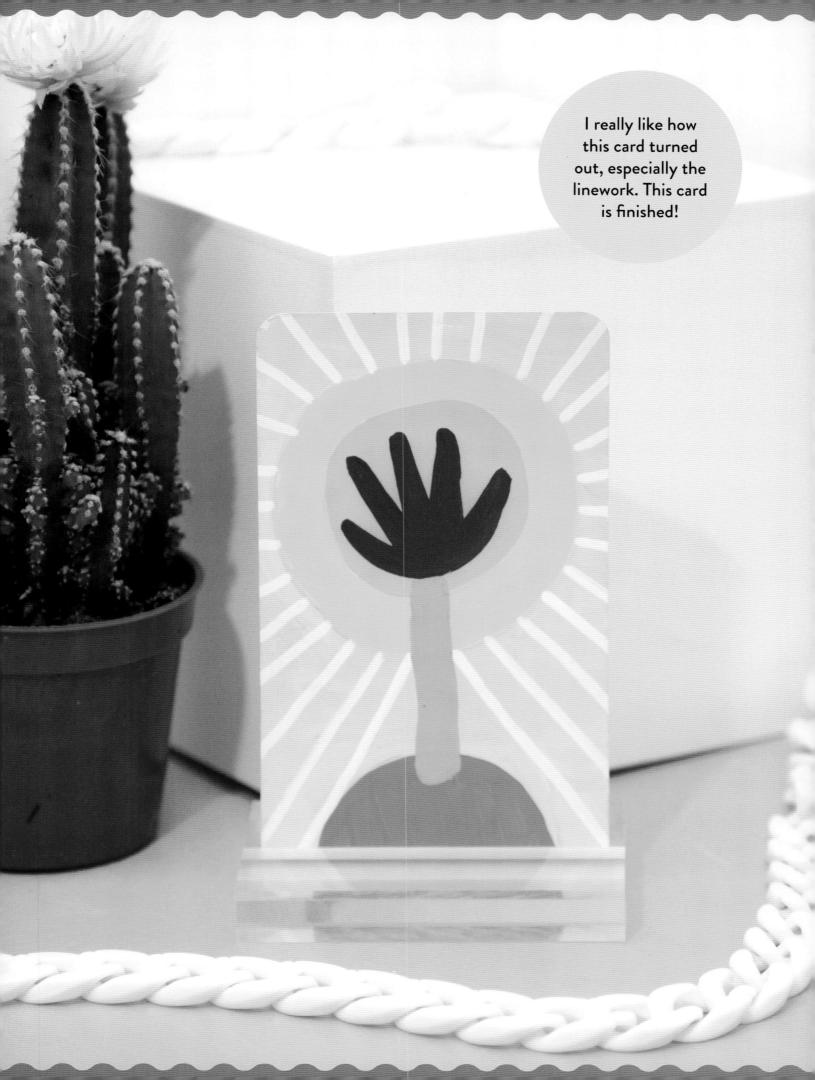

# SIX OF CUPS

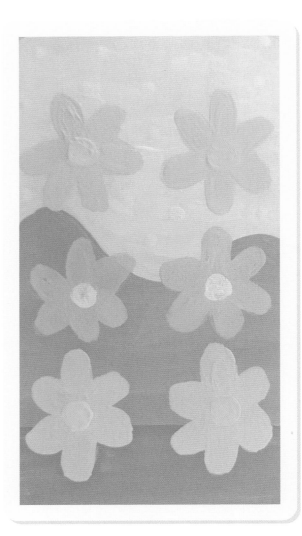

The Six of Cups is a happy card. It's about nostalgia, childhood innocence, and joy. It's a card of pleasant memories and simpler times.

# COLOR SCHEME

## Step 1: Sketch & Prep

The Six of Cups requires six different cups (or in this case, daisies) to be featured. I've sketched two layouts and played with a pastel color palette that's reminiscent of childhood.

Of my two simple ideas, I prefer the one with the mountain in the background. I like the idea of seeing a distant mountain that symbolizes the past.

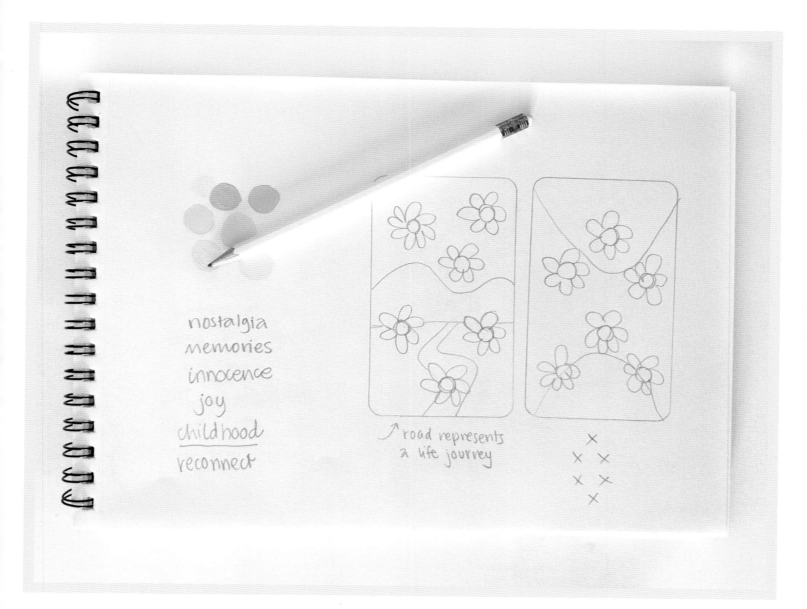

## Step 2: Paint the Background

You can get right to work on the background. This time, I'm using three colors: the sky is a cream-yellow gouache, the mountain is pale lavender, and the ground is misty green. Making the mountains fits with the vibe of my deck. Instead of having sharp corners, the tops are rounded.

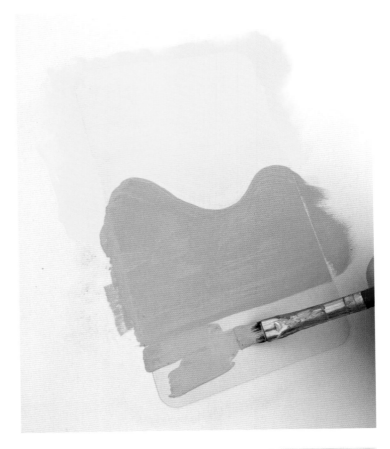

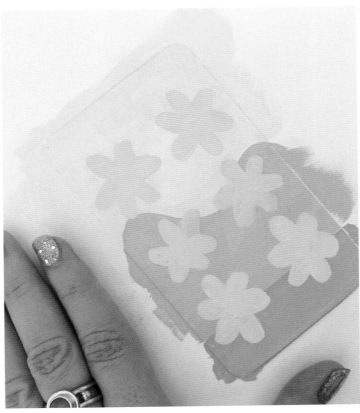

## Step 3: Paint the Foreground

Time to add the "cups," or daisies in this case. Let's use a simple 2x3 layout, and you can get to work painting once the background is dry. The top and bottom rows have pale pink daisies, while the center row has peach daisies. I like alternating colors to add visual interest.

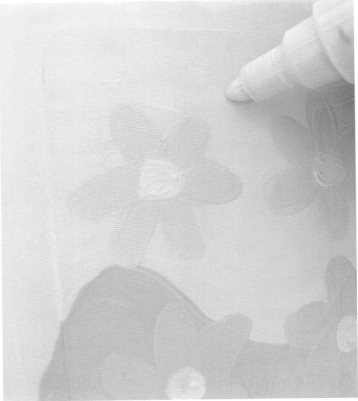

## Step 4: Add the Finishing Touches

The details will be simple for this card: circular centers for the daisies and simple white stars in the sky. I've used a pale lime for the center of the pink daisies and a yellow gouache for the center of the peach ones. Add the stars with a white paint marker.

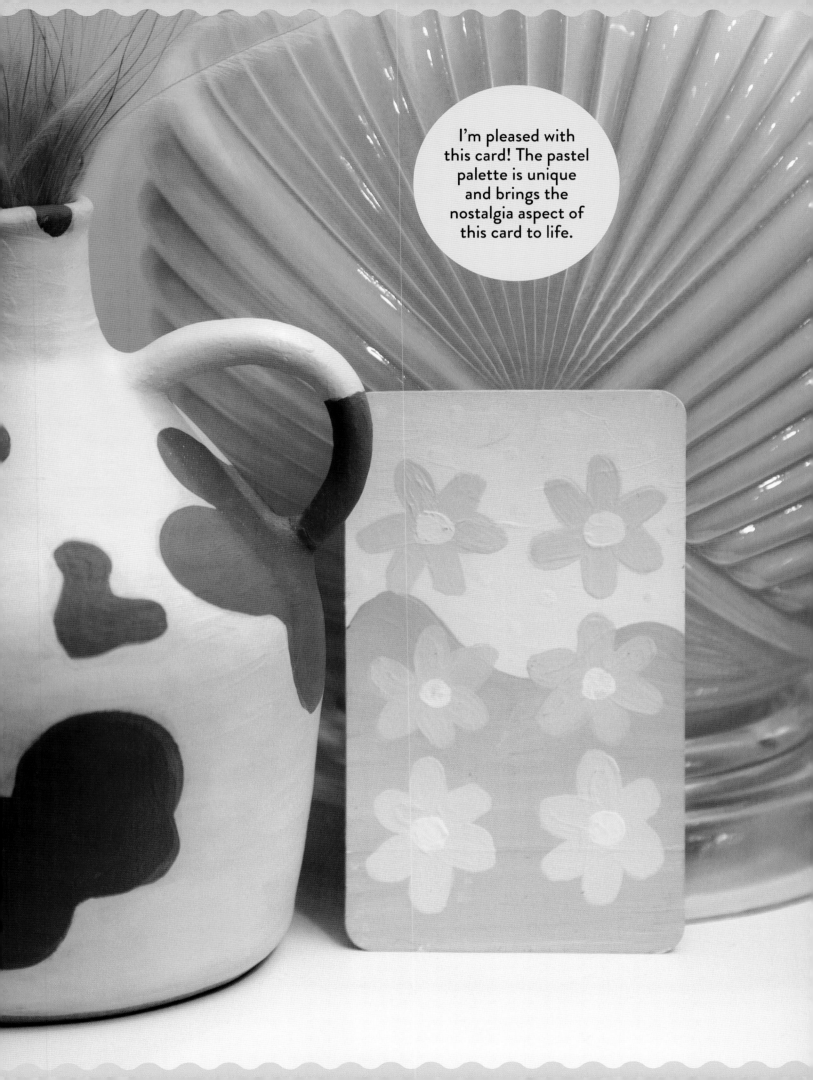

I'm pleased with this card! The pastel palette is unique and brings the nostalgia aspect of this card to life.

# SEVEN OF WANDS

The Seven of Wands card is part of the Minor Arcana. It's a card about standing up for yourself and what you believe in. It's also a tricky card because we'll need to depict seven wands on a small space. Luckily, we have our sketching step!

# · SEVEN OF WANDS ·
# COLOR SCHEME

## Step 1: Sketch & Prep

When you get into the Minor Arcana cards with high numerals, it can be tricky to find a layout that works. As you can see, I've tried two layouts on my sketchpad. I think I prefer the layout on the right because it highlights the center wand, which can symbolize the self.

Since this card is about strength and difficulty, I want a muted palette with pops of bright color. I've chosen some muted blues and then opted for some orange tones, since orange is the complement of blue. For my bright pop of color, I've chosen a fluorescent orange.

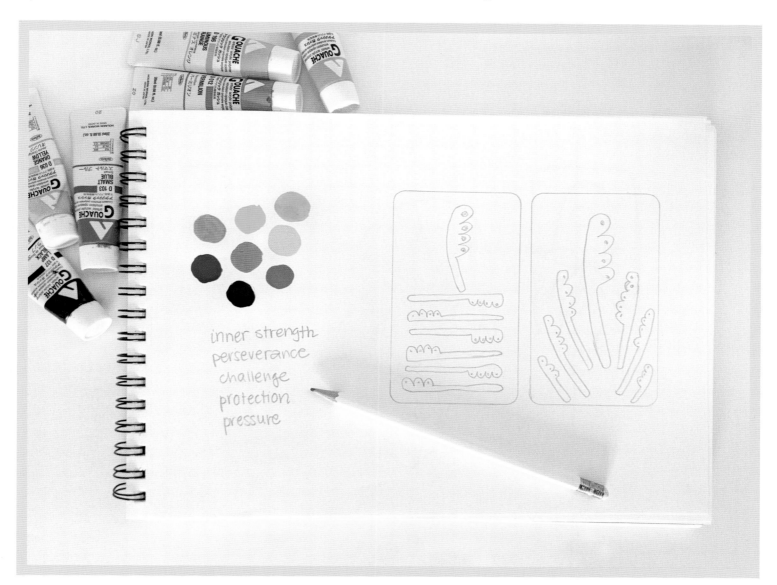

## Step 2: Paint the Background

First, apply an arch to the bottom of the card using misty-blue gouache. Then fill in the rest of the card with deep yellow. You may need two coats for both colors; let them dry before moving on to the foreground.

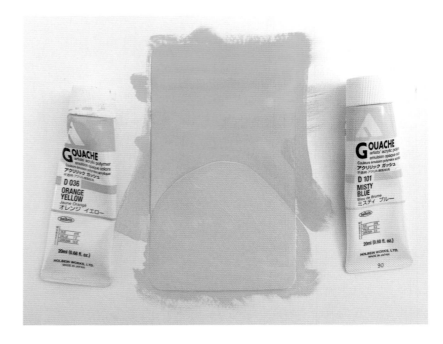

## Step 3: Paint the Foreground

A card like this is tough because there are so many wands to paint! A helpful way to set up a card's layout before you get too far along is to use lines or other simple shapes to create your composition. Since wands are linear, I've painted seven lines in formation and then added the round lumps to the top half. I'm working in alternating shades of red and orange; I think it looks nice against the muted blue. Use a small, fluffy brush to get the fine details.

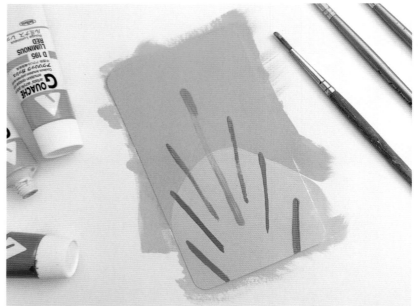

## Step 4: Add the Finishing Touches

For the details step, I've decided to use warm-toned paint markers. Start by adding dots to the center of each lump on the wands. Use royal blue paint to add a half-circle anchor to the bottom of the card.

To add interest to the sky area, use an ivory marker to draw a line across the card. The last step is to add a few orange stars to the sky.

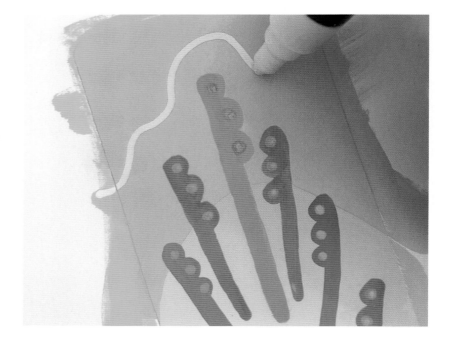

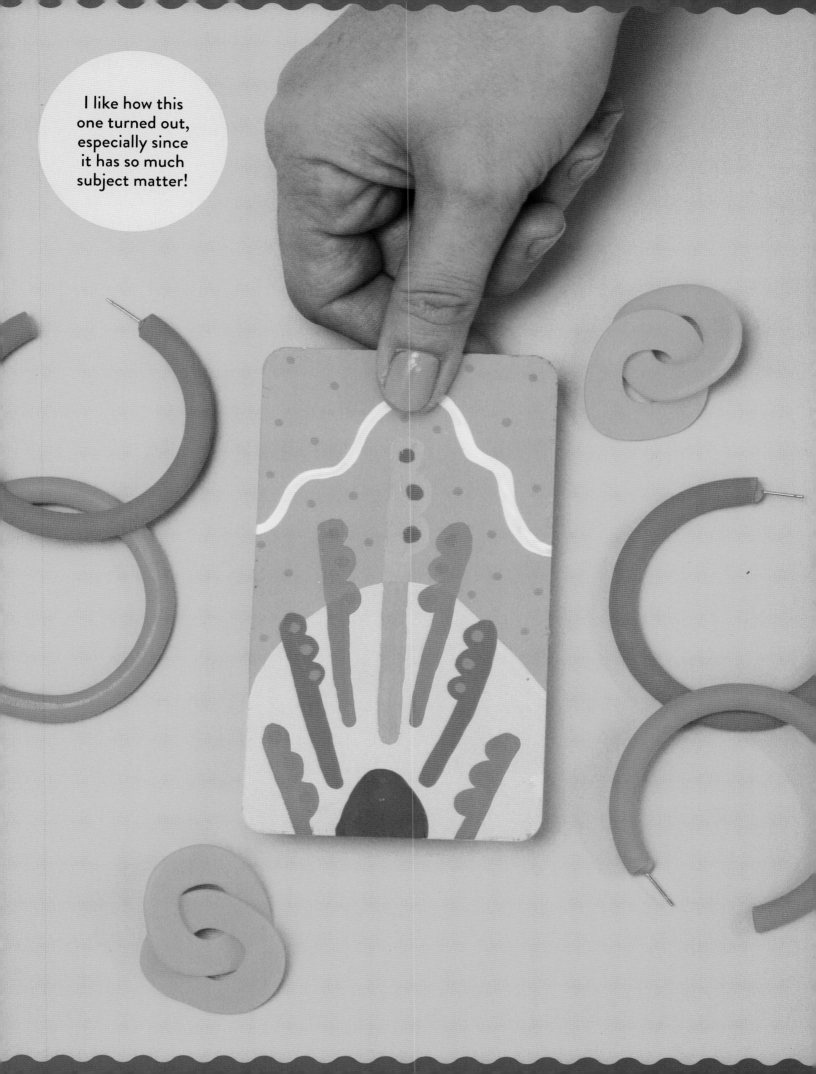

I like how this one turned out, especially since it has so much subject matter!

# TWO OF SWORDS

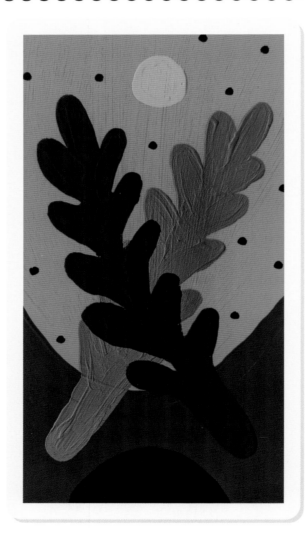

The Two of Swords card is part of the Minor Arcana. This card has more of a negative meaning, indicating a blockage or impasse in life. Something is holding you back and you can't move forward—could you be your own worst enemy?

## · TWO OF SWORDS ·

# COLOR SCHEME

## Step 1: Sketch & Prep

The Two of Swords is about an obstacle, and I want to convey this using the positioning of the swords themselves. These cards are small, so you don't have a lot of room to get your message across. After trying several layouts, the crossed swords depict conflict the best. A darker, muted color palette further symbolizes the darkness and difficulty of this card.

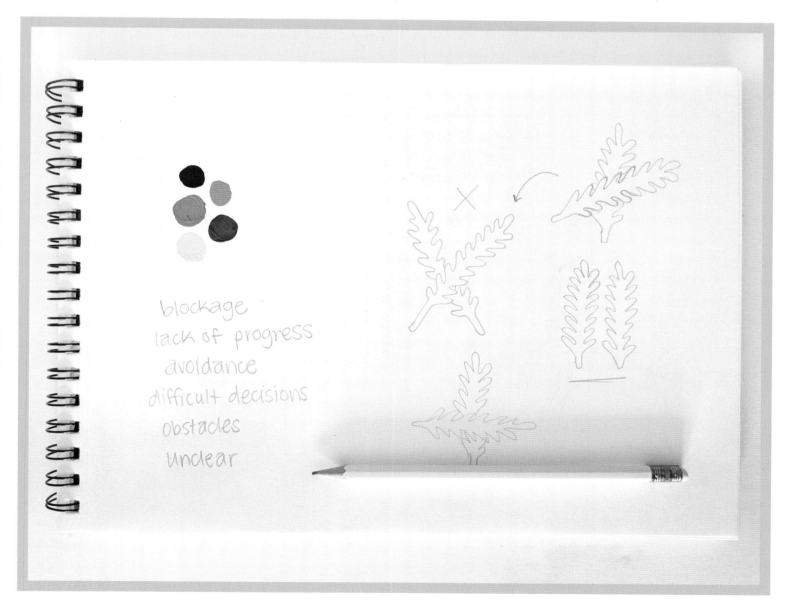

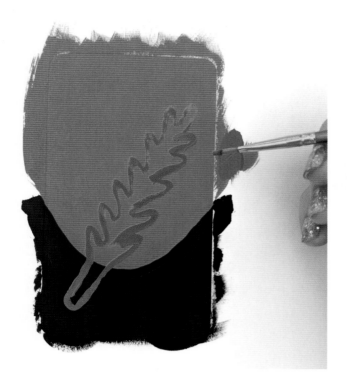

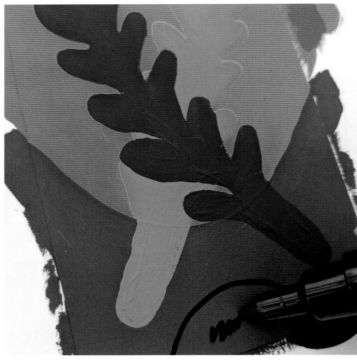

## Step 2: Paint the Background

I've used a bright red for the top half of the card and raw umber for the bottom half. I really want the card to look dark with a hint of intensity (the red). After the background dries, quickly paint an outline of a sword in ash green gouache. I've used this as a test to see if the green will show up on the background and sure enough, it does! If you're happy with the placement of the first sword and the color, fill in the shape.

## Step 3: Paint the Foreground

Technically, you started the foreground in the last step. After letting the first sword dry completely, paint the same shape over the top, forming an X shape. Once you're happy with the outline, fill in the shape using a deep olive green. I really like the texture that's happening on this card!

## Step 4: Add the Finishing Touches

This is a pretty simple card, which may be a welcome break after doing the Seven of Wands (pages 102-105)! Add a quick anchor (half-circle shape) to the bottom of the card using a black paint marker. I like anchors—they visually draw your eye down the card and serve as a nice finishing touch. Then add a coral sun for visual interest and to fill the space between the two swords. I really like how the sky area is in a monochromatic color scheme. Sometimes, less is more with color.

Finally, add a few black stars to the red sky.

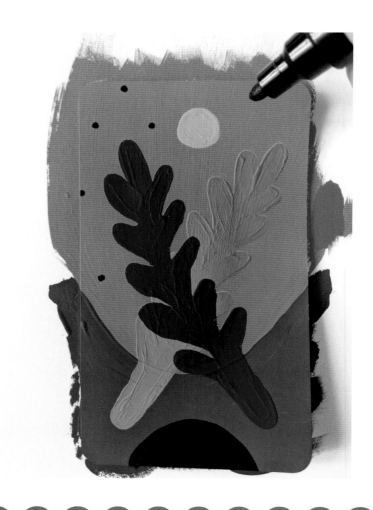

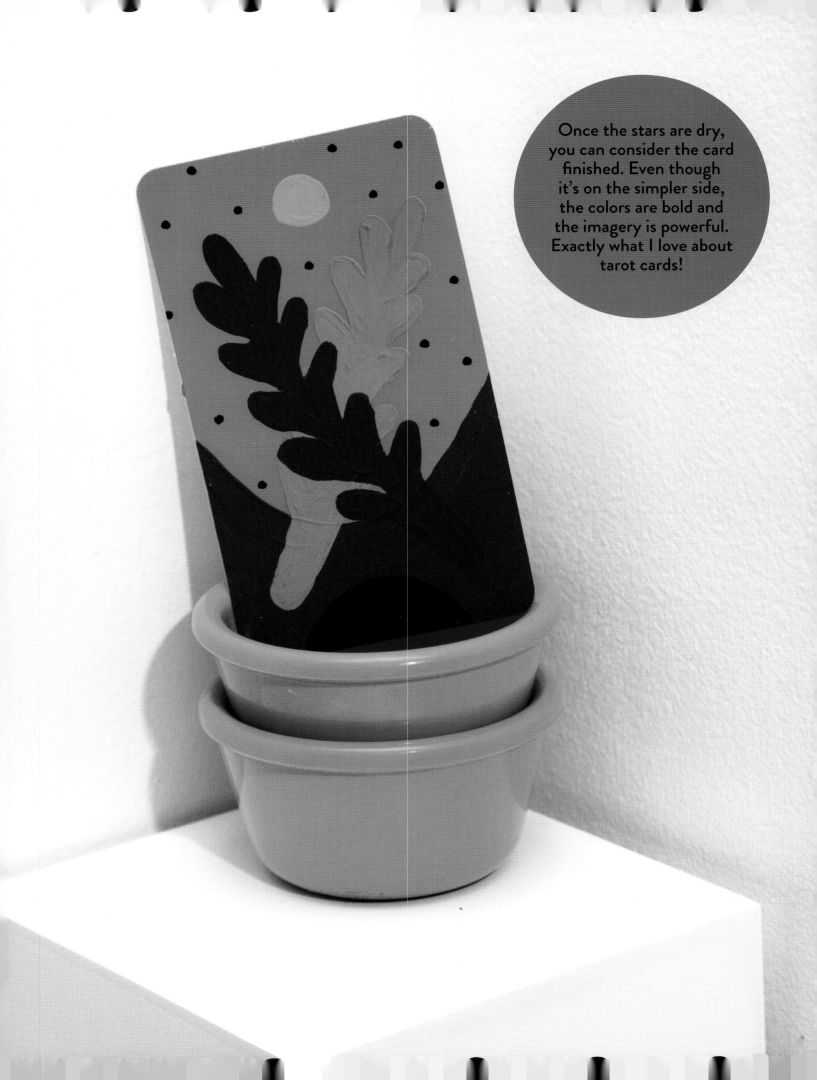

Once the stars are dry, you can consider the card finished. Even though it's on the simpler side, the colors are bold and the imagery is powerful. Exactly what I love about tarot cards!

# PAGE OF WANDS

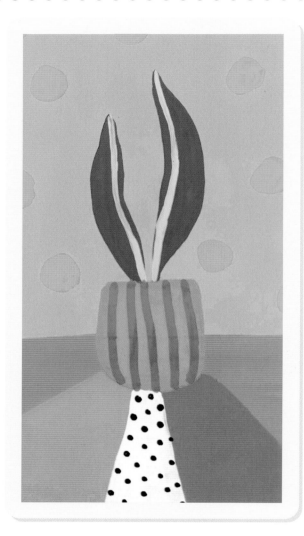

The Wands court cards are part of the Minor Arcana. Since they are a suit of four, you may want to choose a single subject for all of them. I've decided to go with a snake plant, because it's visually stunning and easy to paint at a small size. The Page is the first in the suit, meaning it's the youngest and least experienced. I've conveyed the plant's youth in the final imagery.

# COLOR SCHEME

## Step 1: Sketch & Prep

To prepare, sketch out a few ideas. I've decided to paint the snake plant in a pot and to change the pot depending on the rank of the card (i.e., Page, Knight, Queen, or King). Doodle a bit, thinking about the card's meaning and testing some colors on a sketch pad.

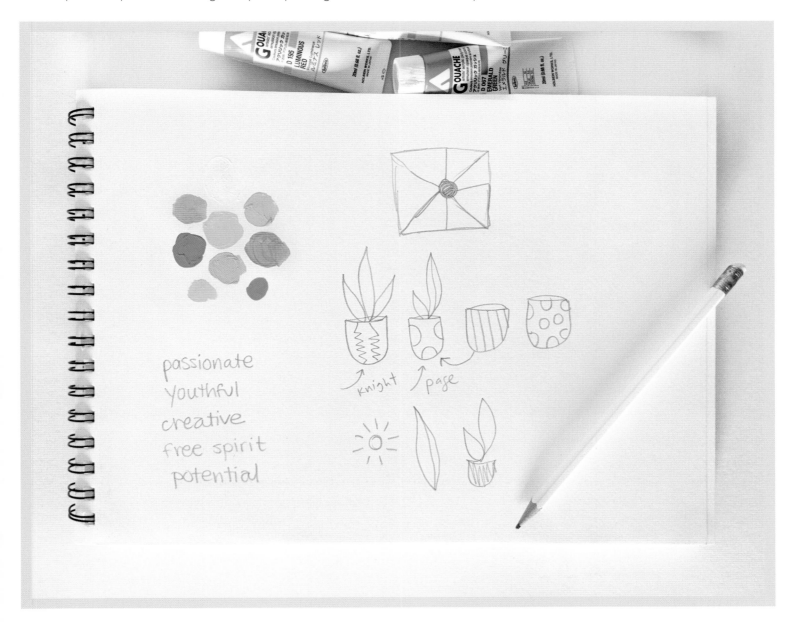

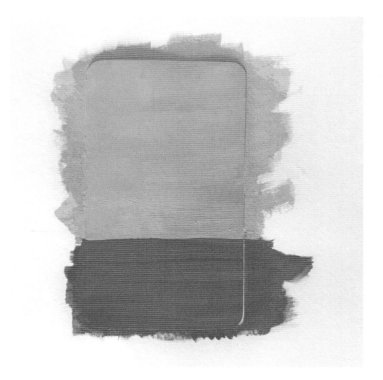

## Step 2: Paint the Background

The Page of Wands symbolizes youthful energy and creative passion, so a bold color will work well for the background. I've chosen light pink gouache for the top two-thirds of the card and neon pink for the bottom third. Apply two or three coats if needed to even out the color. Lastly, set the card in front of a fan to dry.

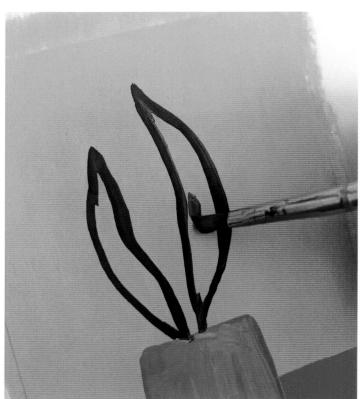

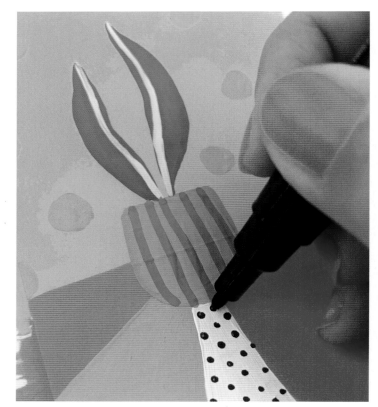

## Step 3: Paint the Foreground

Once the background is dry, it's time to work on the foreground. First, paint the snake plant's pot. I've used sky blue to stand out on the pink background. Next, paint the leaves. The Page is the youngest in the suit, so use the plant to convey that. I've chosen a bright, emerald green for the plant's leaves. To add interest to the surface the plant is sitting on, you can paint triangular washes of color in neon coral, white, and light magenta. Later, add dots to the white area. The neon coral and light magenta are simply there to add interest to the bottom third of the card.

## Step 4: Add the Finishing Touches

Time for my favorite part! Details really bring the artwork to life. To add to this card's theme of youthfulness, create polka dot details in the pink sky using a bright, golden yellow. To give dimension to the leaves, use pale lime gouache to add vertical lines. For the final step, add stripes to the planter using a lime green paint marker, as well as dots in the white area on the bottom using a black paint marker.

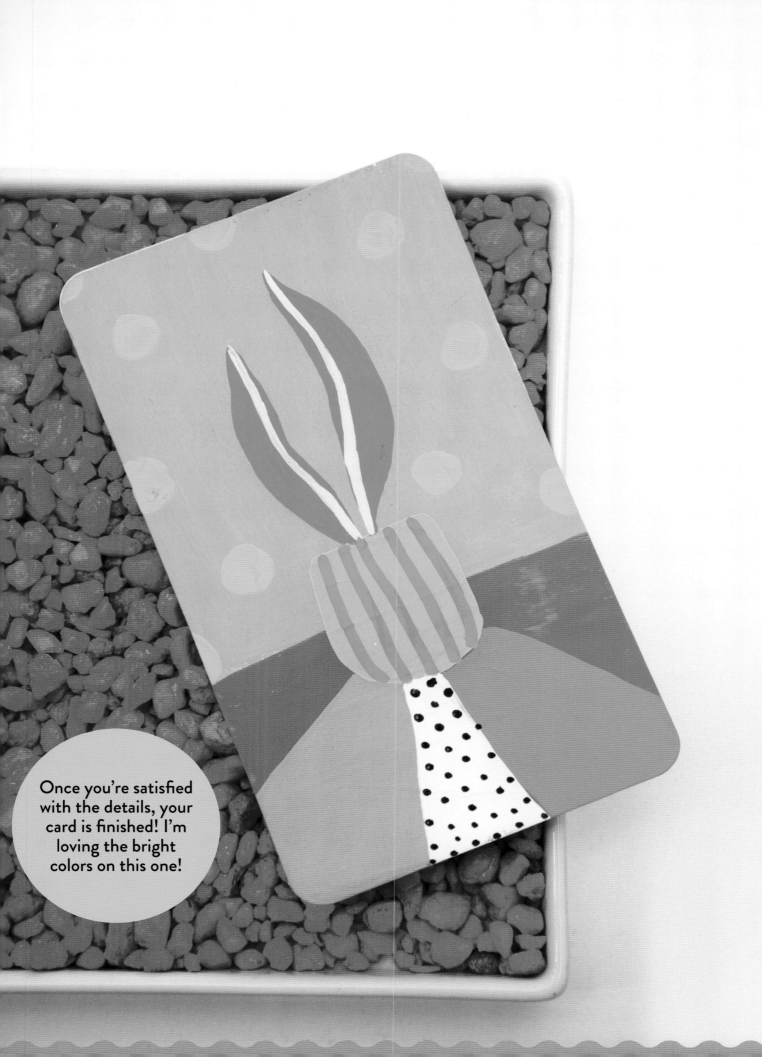

Once you're satisfied with the details, your card is finished! I'm loving the bright colors on this one!

# KNIGHT OF WANDS

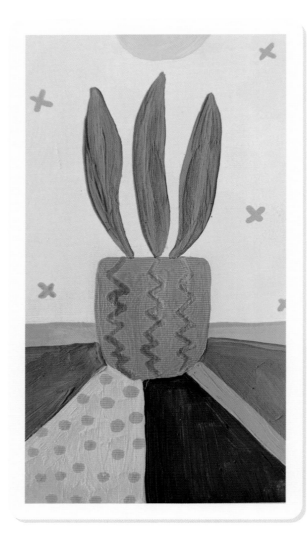

The Knight is the second in the Wands suit. With more wisdom than the Page, the Knight is still pretty naive. The snake plant here should look less mature than the Queen (pages 118-121) and King (pages 122-125), but slightly more mature than the Page (pages 110-113).

# · KNIGHT OF WANDS ·
# COLOR SCHEME

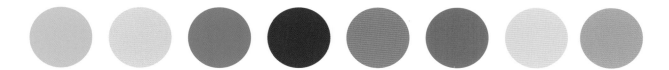

## Step 1: Sketch & Prep

Grab your sketch pad and try some colors. The Knight is adventurous, energetic, and charming, and another bright color palette works here as well. I've used pink for the Page of Wands, so I've decided to go with blues and greens now. Since the Knight is part of the Wands suit and the snake plant was used for that suit, you can plan out a more mature snake plant with three leaves instead of the Page's two.

It's also fun to put lightning zigzags on the pot to represent the card's energetic feel.

Now that you have a loose plan, you can prep the card for painting. Taping off the back of the card is optional—but a good idea if you don't want paint to get on the back edges of your card. Once this optional step is done, you can go ahead and tape your card to a scratch piece of paper for painting.

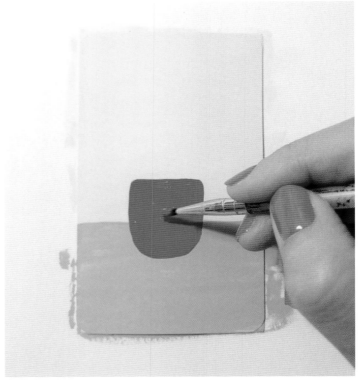

## Step 2: Paint the Background

Look at your sketch pad and choose one color for the top two-thirds, and another color for the bottom third. This background required two coats of gouache.

## Step 3: Paint the Foreground

Once the background has dried, you can begin painting your foreground subject. For the Knight, it's a slightly more mature snake plant. A neon coral makes for a fun pop of color against the teal, and three leaves complete the plant.

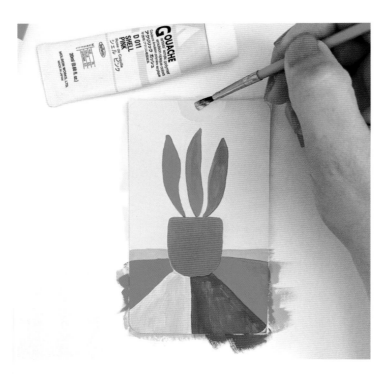

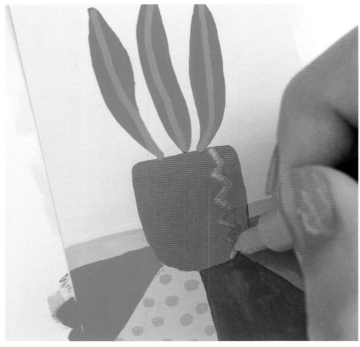

## Step 4: Add the Finishing Touches

Always my favorite part! Jazz up the table that the plant is sitting on by adding triangular washes of color. You may need two coats for the pink color since it's so light. Also, add a neon yellow half-circle at the top of the card to anchor it visually and add interest.

Once the second coat of pink paint has dried, add some coral dots to it.

The final step is adding a pattern to the plant's pot. Take inspiration from the lightning bolts you drew earlier in the process and add zigzags using a sky-blue paint marker.

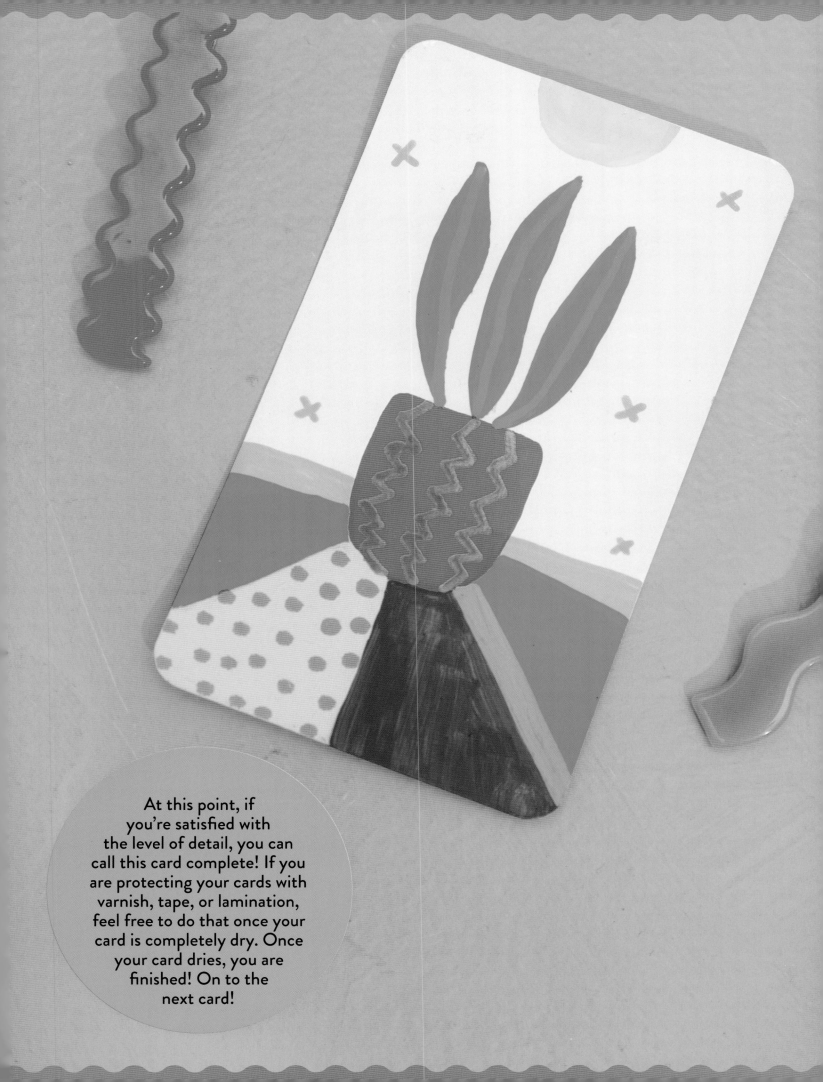

At this point, if you're satisfied with the level of detail, you can call this card complete! If you are protecting your cards with varnish, tape, or lamination, feel free to do that once your card is completely dry. Once your card dries, you are finished! On to the next card!

# QUEEN OF WANDS

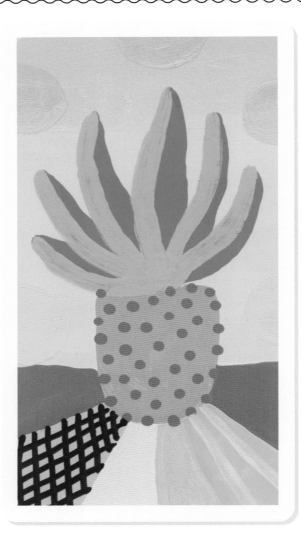

The Queen of Wands demonstrates optimism, grace, and independence. She's a creative spirit as well, with lots of passion. She's courageous when she needs to be, so it's best not to cross her.

# COLOR SCHEME

## Step 1: Sketch & Prep

The Queen of Wands is part of the Wands court cards. Since I've already planned their pot designs (see page 111), I draw all four pots in my sketchbook for reference. I also look at the other Wands court cards (pages 110-117 and 122-125) to orient myself with the composition.

The Queen sits between the Knight and King in rank, so I want the snake plant to be larger than the Knight card, yet slightly smaller than the King. I also want the card to exude warmth, so I choose a warm palette of pinks, yellows, and warm greens.

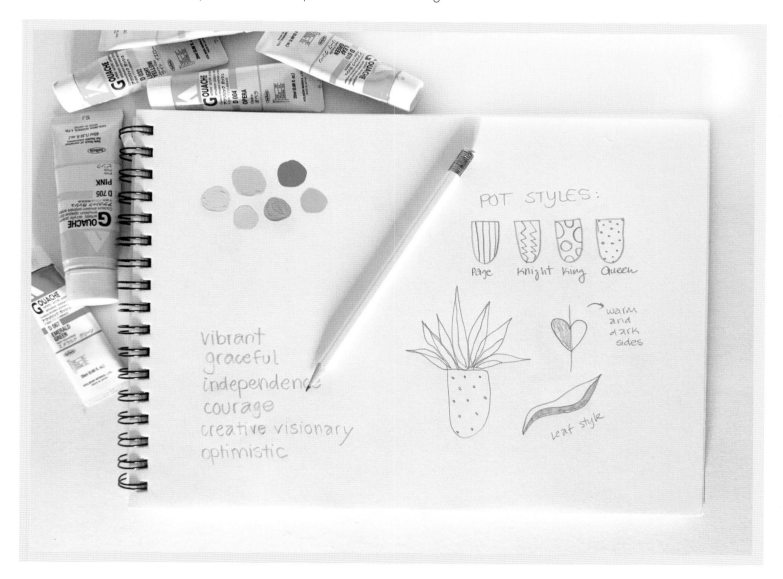

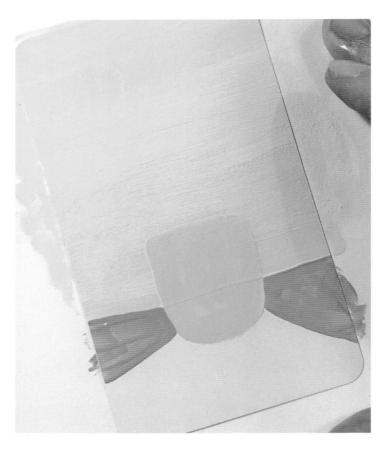

## Step 2: Paint the Background

Start painting the top two-thirds of the card a lemon yellow. Next, add a pink plant pot and, as with the Page and Knight cards, add radiating bands of color to the bottom third, starting with a bold pink.

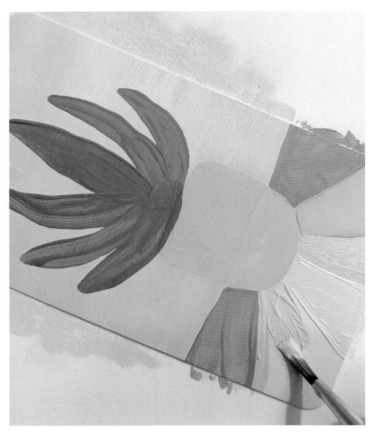

## Step 3: Paint the Foreground

Once dry, add the snake plant's leaves and continue to fill in the bottom with radiating bars of color.

## Step 4: Add the Finishing Touches

As planned, use a pink marker to add tiny dots to the plant's pot. Then use a brush to apply lime-green details to the leaves. The background should be more interesting but not too bold, so you can add slightly darker yellow dots. Then do a cool crosshatch pattern on one of the sections in the bottom third.

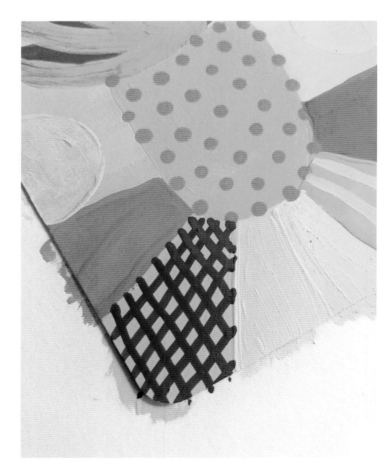

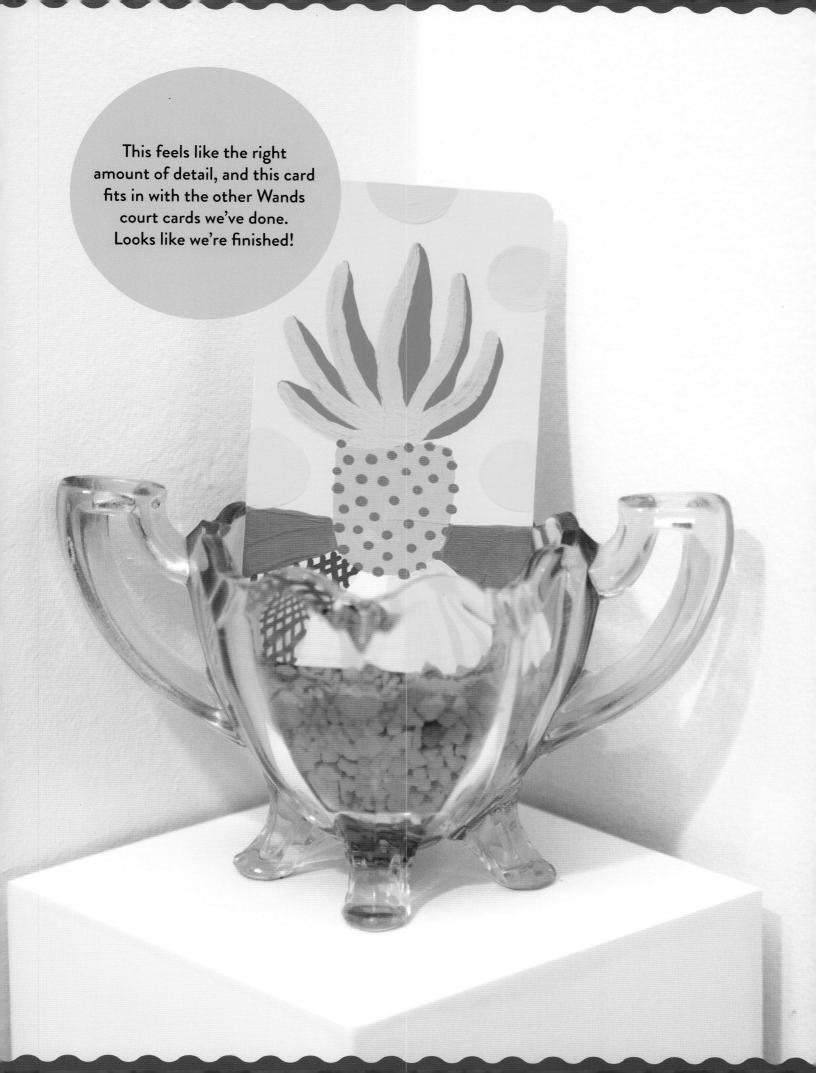

This feels like the right amount of detail, and this card fits in with the other Wands court cards we've done. Looks like we're finished!

# KING OF WANDS

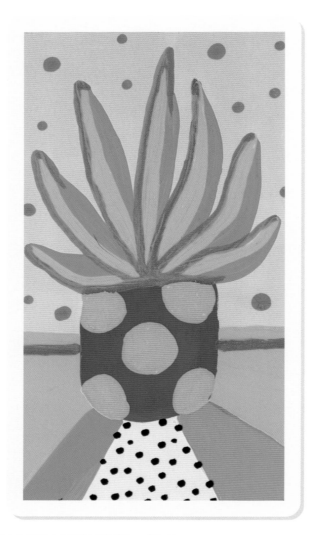

The Wands court cards are part of the Minor Arcana. Since they are a suit of four, I've chosen a subject that works on all of them.

The King is a creative, charismatic, and visionary leader. Also, since the King card is the last in the suit of four, this plant will be larger than all the others.

# COLOR SCHEME

## Step 1: Sketch & Prep

I've done a quick sketch of a really large snake plant in a pot, knowing that the King plant must be the largest of all. I want to give the plant's pot a unique design that's different from the Page, Knight, and Queen's. I've settled on large polka dots because I think they will draw attention in a nice way. I've also grabbed the Page (pages 110-113), Knight (pages 114-117), and Queen (pages 118-121) cards for reference; I want to make sure the King will fit into the suit by following a similar composition.

Go ahead and tape off your card's back, if you are doing that, and adhere your card to a piece of scratch paper for painting.

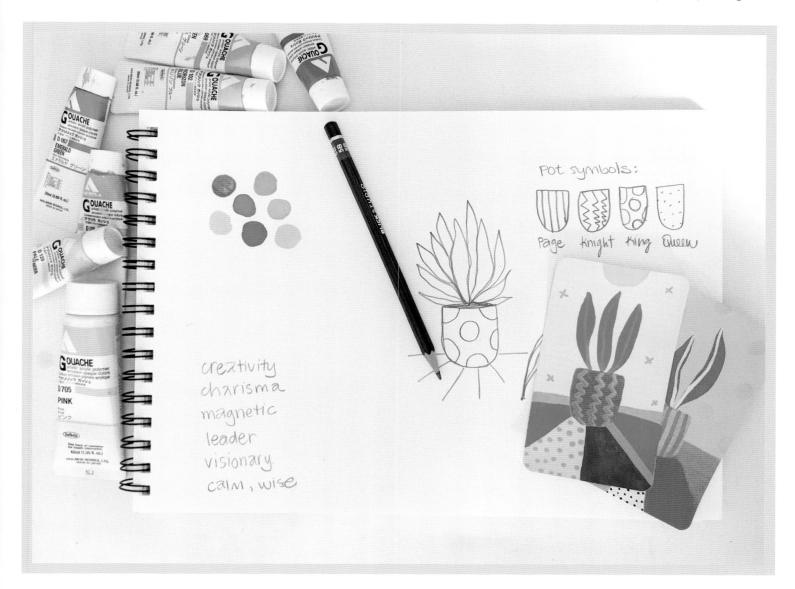

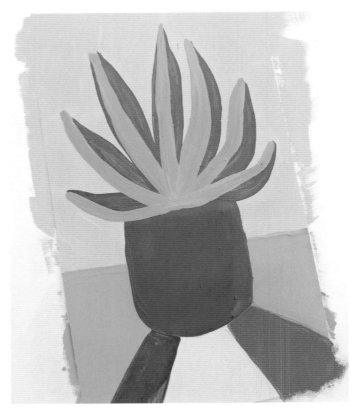

## Step 2: Paint the Background

The King of Wands is dominant and creative, but also stable and wise. To me, feelings of calm are best expressed with the color blue. Therefore, I begin with a pale-lavender gouache for the upper half of the card. Once this layer of color has dried, add a blue plant pot and accent the sides with sky blue (similar to the Page, Knight, and Queen cards).

## Step 3: Paint the Foreground

Once the background dries completely, begin adding the snake plant's leaves. Add as many as you can comfortably fit since we are going for a dominant look. Add mint green to the leaves to give them dimension, and also begin to work on the surface on which the pot sits. Like the Page, Knight, and Queen cards, add a triangular wash of bright color. Neon coral is unexpected and adds some flavor to an otherwise calm color palette. Fill in two other triangular washes of color with green and white.

## Step 4: Add the Finishing Touches

Now is the time to make this card a bit more fun! Use a blue paint marker to add dots to the sky in slightly different sizes. Then add small dots to the white area in the foreground. Finish up the card by adding pink dots to the plant pot and going over the edges of the plant's leaves with a green paint marker.

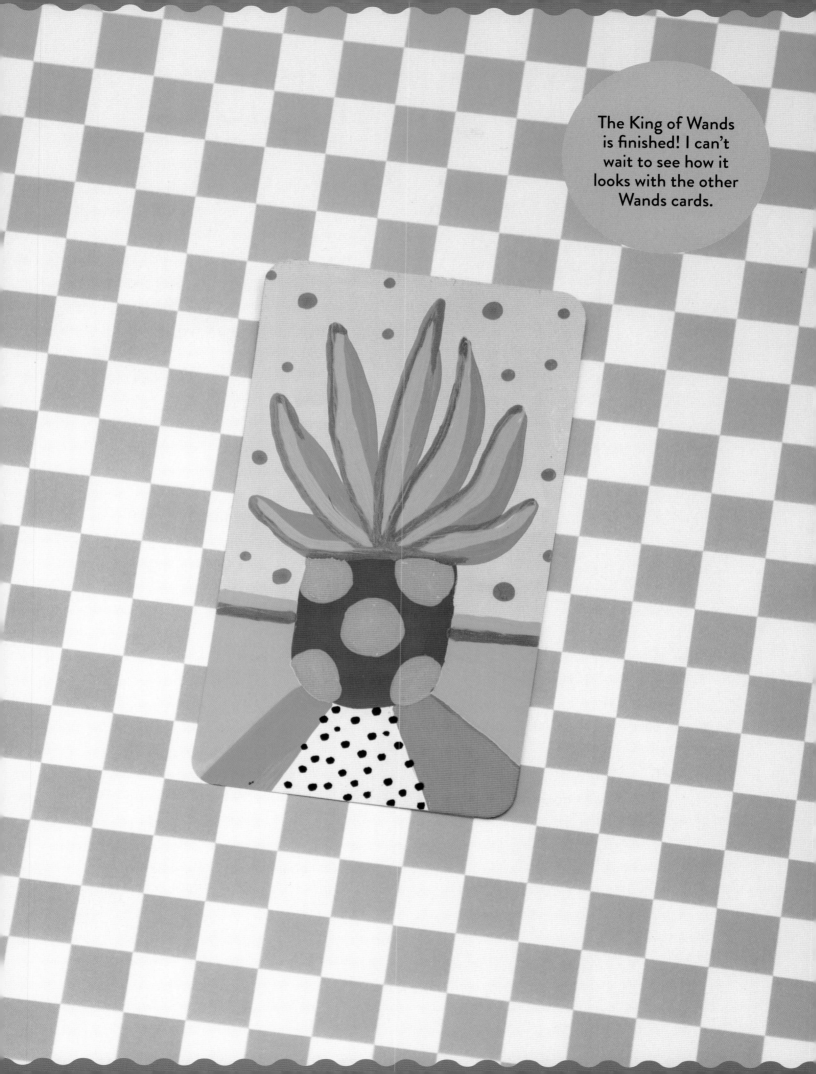

The King of Wands is finished! I can't wait to see how it looks with the other Wands cards.

# ABOUT THE AUTHORS

## Theresa Reed, The Tarot Lady

Theresa Reed, aka "The Tarot Lady," worked as a full-time tarot-card reader for more than 30 years. She is the author of *Tarot: No Questions Asked: Mastering the Art of Intuitive Reading* (Weiser Books) and *The Tarot Coloring Book* (Sounds True), an illustrated tour through the world of tarot. Theresa is also the author of *Astrology for Real Life: A Workbook for Beginners* and the co-author of *Tarot for Troubled Times* (both from Weiser Books). Her latest project is *Tarot for Kids*, a kid-friendly tarot deck with artist Kailey Whitman.

In addition to writing, teaching, podcasting, and speaking at tarot conferences, Theresa also runs a popular website, TheTarotLady.com, where she dishes out advice, inspiration, and tips for tarot lovers of all experience levels. She also hosts two educational podcasts, "Tarot Bytes" and "Astrology Bytes," which have been downloaded by millions of people around the world.

## Adrianne Hawthorne of Ponnopozz

Ponnopozz is the art and studio of Adrianne Hawthorne.

Adrianne uses vivid colors in unexpected combinations to create wild, colorful acrylic and gouache paintings. Color has always been her main source of inspiration.

Adrianne comes from a graphic-design background but prefers the act of making art with her own hands. She initially felt uneasy putting so much of herself out into the world—but has since felt a satisfaction that she never found in corporate America. Ponnopozz is named after two imaginary friends, Ponno and Pozzer, that the artist had as a child. The name is a daily reminder of the unbridled creativity of childhood that she continues to nurture through the act of painting and drawing.

Adrianne is currently based in Chicago, where she owns and operates the Ponnopozz Studio and Store. She lives with her partner, Seth, and their three cats.

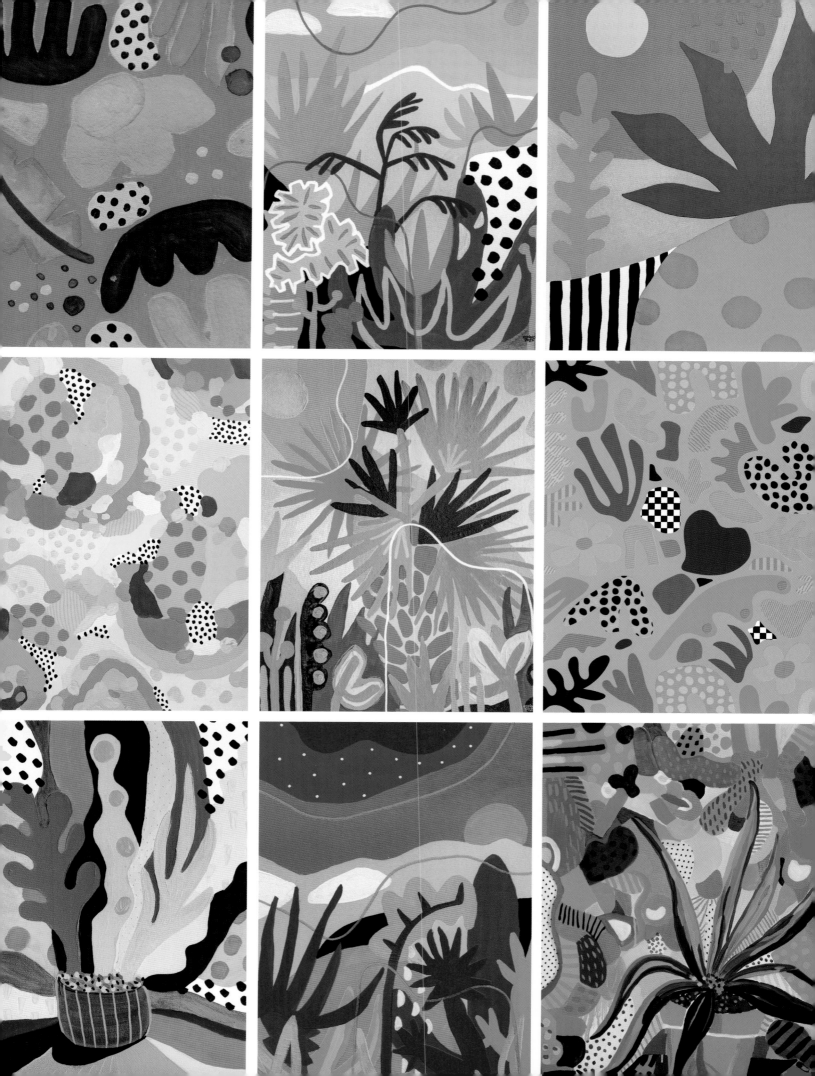

# CARD TEMPLATES

Use the included card templates and the tarot and painting tips
throughout the book to create your own tarot cards!